Copyright Law for Writers, Editors and Publishers

Copyright Law for Writers, Editors and Publishers

Gillian Davies

in association with
Ian Bloom, Ross & Craig Solicitors

A & C Black • London

First published in Great Britain 2011
A&C Black Publishers
an imprint of Bloomsbury Publishing Plc
50 Bedford Square
London, WC1B 3DP
www.acblack.com

ISBN: 978-1-4081-2814-5

A CIP catalogue record for this book is available
from the British Library

Cover design: Sutchinda Thompson
Series and page design: Susan McIntyre
Publisher: Susan James
Project manager: Davida Saunders

This book is produced using paper that is made
from wood grown in managed, sustainable
forests. It is natural, renewable and recyclable.
The logging and manufacturing processes
conform to the environmental regulations of the
country of origin.

Printed and bound by Star Standard Pte Ltd,
Singapore

Contents

Acknowledgements

Thank you to The Authors' Foundation, managed by The Society of Authors, for helping to support me financially and enabling me to spend the time needed to research this subject. I hope it helps all authors, editors and publishers better understand a complex area.

I am indebted to Ian Bloom for taking the time to read the entire typescript, and for his insightful contributions on plagiarism, libel, privacy, contracts and access to the law. Ian has been a media lawyer and publishing law expert for many years, and has become something of a mentor to me. I am grateful to him for his help and good humour.

I also thank Stephen Simou for casting his expert eye over Chapter 19, Maximising Earnings: Tax, VAT and royalties.

To the others who have helped by offering expert advice, for sharing experiences, dealing with admin or offering ideas, and for getting back to me in general, I thank, in alphabetical order: freelance editor, Helen Bleck; graphics genius freelancer, Tami Cohen; Richard Combes of the ALCS; esteemed musician Robert Fripp; the Scottish Parliament's Claire Hall; Merlin Holland and Robert Kirby for the Estate of Oscar Wilde; Mark Lambert, senior lawyer, Channel 4 Television; Jon Lellenberg for the Conan Doyle Estate; Lisa Moldau of the Music Publishers Association; Ruth Searle of The Music Sales Group; patient and wise editor, Davida Saunders, at A&C Black; and Paul Shannon at R.R. Bowker.

Preface

Like my book on artists' copyright, this is a personal journey, a personal insight into a subject that fascinates me.

But, unlike the artists' copyright book, there are lots of other materials you could choose to read on this subject: I have listed some of the best in the Resources at the end of the book. As to why you should read this one – well, see below.

Copyright applies in multiples, and separately for all media 'expressions' of works. The same strong legal copyright protection exists for paper, ebook, or online forms: the only important thing about choice of media is the difference between published or unpublished works; and the degree of commerciality of the product (the more 'commercial', the more public, the stronger the copyright rights, and the more likely you are of getting into trouble if infringing someone else's copyright); and with the internet, the reach of the content.

A quick note about terminology: 'literary work' for copyright legislation, the Copyright, Designs and Patents Act 1988 (this 1988 Act is our current UK law), is not in any way indicative of quality – railway timetables, recipes, compiled basic information, translations, eroticism, lyrics, questionnaires, exam papers, computer programs, the summarising headnote of a report of a legal case, labels and packaging – can all be protected by copyright just as much as poetry, fiction, scripts and comedy. Copyright applies to all original work, the good the bad and the ugly.

Copyright itself has changed meaning through time. When John Milton sold *Paradise Lost* on 27 April 1667 to Samuel Simmons for £5 (and £5 more after the first print run of 1,300), Milton was selling 'his copy' (meaning his right to publish). Equally, when Charles Dickens took an (as it happens pretty ill-fated) legal action to try to protect *A Christmas Carol* when another publisher published a competing edition, he was fighting to protect his exclusive right to print and publish his work (the defendant, Parley's Illuminated Library, was unable to pay for the legal action, declaring itself bankrupt, and Dickens ended up paying legal costs of £700).[1]

I am not going to discuss photocopying – but suffice to say that copyright law is very strict and the Copyright Licensing Agency (CLA) polices its licences rigorously. Photocopying work instead of buying it is one of the most obvious copyright-infringing activities; as is logging on to a subscription-only site with somebody else's password; as is cutting and pasting work on to the internet or 'deep-linking' to it. But the exclusive right to copy, including photocopying, is at the heart of copyright law and benefits authors – even, and perhaps especially, 'jobbing' writers like myself – in that the Author's Licensing and Collecting Society (ALCS), negotiates licences with universities, libraries etc. and the result is, hey presto, money made available as royalties to published writers: all you need to do to collect cash from the pool is declare your work to the ALCS (see Chapter 15 for this and other useful sources of extra income).

I am also going to deselect 'compilation cases' – such as *Elanco* the 'weedkiller' packaging case – because, well, I think they are wrong. (They are NOT 'wrong', they are the law: they say that non-literary publications that take independent labour and research to produce should be covered by copyright, things including weedkiller tin labels and bookmakers' betting slips. But they are not really the stuff of literary authors or even of non-literary authors ... so I am going to ignore them).

So why write this book when there are so many others? It's one in a useful series by the publisher. As a law editor, I have access to court judgments which can be both hard to obtain and to understand. Many of them are ancient and arcane (but still 'current law' despite dating back to the 19th century). The case summaries here are the product of my own labours. If they are wrong the errors are mine. And, technically, sometimes they *will* be 'wrong' in at least one sense because with legal judgments one is meant to extract the 'ratio' of the case: the main legal meaning and implications. One is not supposed to dwell too much on the *obiter dicta* or *per incuriam* statements of judges, but at times I have highlighted those because they are interesting asides (in the non-Shakespearean sense).

Some may feel I am a bit flippant at times. I plead guilty-ish. That is my style, and I hope to convey some of my enjoyment of this subject so you can be entertained as well as informed. Please immediately go to the discussion of the *Confetti Records* case in Chapter 14, Moral Rights, Satire and Parody, if you want a laugh!

Literary copyright is harder to write about than art copyright because there has been more ink spilled on the subject – by both authors and the courts (there is much more case law to cover) – but also because literary copyright is intellectually trickier than copyright expressed in art form. Literary works are less easily separated out from the idea and the expression of that idea in physical formats (see Chapters 3, No Copyright in 'Ideas'? and 13, Journalists and Newspaper Editors).

If you are employed the copyright in your writing will normally belong to your employer. Most of this book is not written with that in mind.

The law – or at least my understanding of the law – is as at 1 June 2011. I realise that the review of the UK's copyright law by Professor Ian Hargreaves was published in May 2011, but I have resisted a late addendum to this book on the grounds that until the proposals become law, I wanted to discuss the legal position as it is currently – not to speculate on what changes might be introduced.

I am hoping that this *Essential Guide* fuels debate and thinking. The lawmakers are interested; we need more input from writers, editors and publishers.

DISCLAIMER

I am an artist and writer/editor with a law degree who works with legal texts as a law editor and writer, I am not a lawyer and am not providing legal advice. I use the names Gillian Davies and Gillian Haggart. I am not the Gillian Davies, a barrister, who currently edits the leading copyright text for lawyers, *Copinger & Skone James on Copyright*.

Gillian Davies, MA(Hons), LLB; lawandarts@aol.com

INFORMATION BANK

[1] Peter Ackroyd, *Dickens* (Sinclair-Stevenson Limited, 1990), p.416.

1

Introduction

The law of copyright may seen confusing, so I will try to set out the basics up front. (Unless you are already an expert, do not expect to actually 'understand' this; just let it wash over you. It may come in useful when reading case summaries later in the book. It is the sort of thing that only makes sense once you have read more on the subject.)

So anyway, allow the following 'warm waves of copyright logic' to flow over you as follows:

- Copyright is a negative right: it is not a right of possession, it is a right of exclusion.
- It does not protect property but intellectual property – which is not the same as 'ideas'.
- The UK statute (Copyright, Designs and Patents Act 1988) grants exclusive rights to originators of copyright (it calls them 'authors', but they are not 'authors' in our more strict sense of the author of a book. It is a technical legal term).
- The exclusive rights include the right to copy. So, if you are not the copyright holder or licensee you do NOT have the right and must not copy or else you must pay to copy. Exclusive rights also include the right to alter and issue adaptations.
- All powers are put in the hands of the copyright owner who is then given the opportunity to whittle down or license or assign all or some of their rights. This is where licences and contracts come in.
- Moral rights are also the authors', in addition to economic copyright rights. They cannot be assigned; but they can be 'waived'.
- You can challenge someone else's copyright by various routes: no copyright may ever have existed, for example, because copyright has been given away, or because copyright – which is time-limited on public policy grounds – has lapsed and fallen into the 'public domain'.
- You can also challenge copyright by invoking a defence (correctly called an 'exception'): 'fair dealing' in the UK; 'fair use' in the USA (e.g. 'I was reporting current news').

- Then there are some complications: you could also challenge a copyright claim by saying there was an implied licence to use (not an explicit one).
- Or, in even more special circumstances, you could say there was an equitable reason for the action you took; or a constructive trust.

Copyright earns people money. That's where royalties and licence fees come in. The sums of money involved can vary from the miniscule to huge.

The Ordnance Survey, for example, won £20 million from the AA because of unlawful copying of 26 million of its maps; the Publishers Association secured £75,000 from a local authority which had photocopied a maths textbook instead of buying it (discovered by the author who was supply teaching at the time);[1] and Designers Guild received £10,000 from a small textiles business at the turn of the millennium, although the legal costs payable by the losing party in that leading case were in six figures (on top of the £10,000).

The costs of going to court can, and likely will, be high, so it is worth avoiding litigation if at all possible. (See Chapter 18, Going to Law.)

Everything that follows in this book is unnecessarily complicated. It is not me – it is the law. Where possible, I have tried to make my summaries accessible, but ultimately there is a lack of coherence and many contradictories within case law, so it is no fault of mine – or of yours – if it seems unfathomable at times. There are grey areas (which ultimately means you could argue the issues one way or the other) in particular on:

- the protection of transcripts of speeches
- joint works
- compilations, and
- the big one: the protection of ideas.

That said, if you can get to grips with the main principles, you will equip yourself with the knowledge to stay within the law, while getting the best out of your own intellectual property. And you may be surprised at just how much of your work is and can be protected – and how fiercely.

INFORMATION BANK

[1] Pedley, *Copyright Compliance* (2008).

2

How Issues can Crop Up

The law differentiates between 'real' property and 'intellectual' property (IP).

The best way to understand this in copyright terms is to consider what happens when you die (just to be cheery for a moment). Any copyrights you own, and any Public Lending Right (PLR) (see Chapter 15, Dates, Deadlines and Money) – but not moral rights – can be passed on by you, as with all other property, in your Will. So your child could receive future royalties, or be entitled to negotiate licences for your work, or agree on your behalf whether or not to publish something that was unpublished when you died. If you do not address these issues in your Will, your manuscript, and your copyrights, will pass by default into the 'residue' of your estate (as opposed to 'specific legacies'). Your lawyer would do different things in relation to each (specific legacies/residue) when distributing your assets to the correct people. But in theory the copyright in a manuscript could be hived off from the physical manuscript, be it in paper or digital form. Your son could get the actual notebook, your daughter the copyright (e.g. the right to sell a piece of fiction for film rights; the right to say 'yes' or 'no' to someone who wants to quote a chunk of your memoirs in a newspaper, etc.). That is how copyright works, technically speaking, but because it doesn't make all that much sense in real, practical terms (how could the film producer actually access the text if your son has the notebook under his bed?), the 1988 Act will 'deem' that, unless the contrary is specified, the copyright will pass along with the physical manuscript to the same person or persons.

As with real property, however, copyright can be sold as and how you like – subdivided and separated into parts potentially owned by different parties, each of whom could own different kinds of rights for different kinds of uses.

Kill fees

Still on the subject of death (excuse the pun), being paid a 'kill fee' by a publisher who no longer wants to run your piece simply means you are being paid for your time. It has no effect on copyright, so if you kept the copyright in the piece, but see it published later by that publisher, you have a cause for complaint (and recompense) under copyright law, as well as a case for breach of contract. But if you licensed or assigned your copyright to the publisher, then it can do as it wishes with the piece. (But you are likely to have a separate legal cause of action under contract law for the full fee and not just the kill fee.)

Scenario I (real/historical)

Charles Dickens was one of the earliest writers to fight for his 'copyright', although technically copyright meant something a little different in the 19th century, because the right was much more clearly linked to the right to print/publish (it was the sole right of first printing and publishing a work for sale). Today, copyright covers a broader host of exclusive 'rights', to include for example the right to adapt, as well as the right to publish, as you will see later.

The following summary is from a real case, and sheds light on the physical object/intellectual property difference.

In Re Dickens/Dickens v *Hawksley; In Re the Estate of Sir Henry Fielding Dickens*, Court of Appeal 7 December 1934, [1935] Ch 267. This case involved the interpretation of the Wills of both Charles Dickens (died 1870) and one heir to part of his estate, his sister-in-law, Georgina Hogarth (died 1917). Two factions of the Dickens family were contesting which side was entitled to publish an unpublished work by Charles Dickens, which had no formal title, but which was known variously under different informal titles including *The Life of Christ*. The story was written in Dickens' handwriting, apparently purely for the instruction of his children. One copy existed, owned by his son Charles Dickens Jnr.

It was agreed by Charles Dickens' immediate family after his death that the unpublished work should remain unpublished, as the author never intended it to be public. But, as happens and skipping a generation, the question arose again and family members wanted to look into publishing it posthumously in 1934.

They needed the courts to decide a legal question because, depending on how Charles Dickens' will was interpreted, the right to publish – 'the copyright' in that historical sense – could

belong to one side rather than the other: it could have been part of a 'specific legacy' falling under the category of 'private papers' belonging to the late author; or, it could have fallen into the 'residuary estate' (everything that is not specifically accounted for in the Will) and therefore belong to all his children to divide among them. In the end, the Court of Appeal applied equitable principles to come up with a sort of 50–50 solution, but in doing so affirmed the different treatment of tangible versus intangible (intellectual) property:

The Court held that gifting the manuscript to Georgina Hogarth (GH) was a gift of the physical object and not necessarily also a gift of the copyright; the copyright fell to the other side – the residuary estate – and GH had no right necessarily to restrain publication of it if the other side of the family wanted to publish. The Court of Appeal referred to the fact that the 1911 Copyright Act makes this clear (and all subsequent Acts that deal with copyright also make this clear). The 1911 Act, incidentally, was also the first UK Act to protect unpublished works.

According to Lord Justice Romer: 'the bequest to Miss Georgina Hogarth of the manuscript of *The Life of Christ* did not pass to her the incorporeal right of Charles Dickens in the composition.'

The physical object/IP split was decisive and applied by the Court, despite the fact that such ownership of the intellectual property in the manuscript could boil down in practice to a pretty 'worthless' right – because ultimately the person in physical possession of the manuscript can block the IP rightsholder if she wanted:

> 'Miss Hogarth could not have been compelled to part with the manuscript or to allow it to be copied, and had anyone copied it without her consent she could have restrained any publication being made by means of such copy.' Lord Justice Romer

There is an interesting *obiter* in the case, too, about letters:

> '... the question is one of vital importance where the manuscript is in the possession of some person other than the author. This, of course, usually happens in the case of letters. The manuscript is in the physical possession of the recipient of the letter. It has nevertheless been established by numerous authorities that the writer of the letters may restrain publication. ...' Lord Justice Romer citing *Jefferys v Boosey* [1854] 4 HL Cas 815 PC.

Scenario II (hypothetical)

I write a letter to the Editor of the *Guardian*. I retain copyright in the letter, but the *Guardian* receives the actual physical letter – the 'real property' – and with it, probably, an implied licence (permission) to publish the letter. (Unless, perhaps, I have tried to expressly prohibit publication).[1]

So, accepting the idea that IP is different from real property helps us to understand how copyright works.

Another basic concept is multiple copyrights in a single work. For example, copyright in the text of a book may belong to one or several people; copyright in the artwork may belong to someone else; copyright in the design and layout to another person; and copyright in the book as whole is usually owned by the publisher. The publisher might also have a separate copyright in the typographical arrangement of the book. A photographer might own copyright in photographs she has taken of a painting which illustrates the book. Many people may be involved, which is why sensible publishers get copyright assignments from everyone involved. Another example might be a piece of audio footage on the internet: there may be separate copyrights for lyrics, performance, mechanical rights, text copyright, and a voiceover, as well as the director's overall cut.

Scenario III

I have met the partner of my dreams. We are joined at the hip. We think alike, we act alike, we look alike. He is brainy, I am brainy. I write a book, he writes a book. They are both the 'same book': same plot; same language; same style; same character names; same premise; same language and vocabulary; quite often the same turns of phrase. If you were only just learning English as a foreign language you might mistake them for identical texts. But they each have separate copyrights because there is no copyright in ideas – only in the physical expression of those ideas and the two works were independently created. Heck, even if they were somehow word-for-word identical, technically, for copyright, there are two separate copyrights in these two independently-created 'works'.[2]

That is the overarching point. Sub-points are that there is not necessarily copyright in a character *per se*. As I write, I understand that John Savage is suing Ricky Gervais because Gervais' book

Flanimals seems a lot like Savage's *Captain Pottie's Wildlife Encyclopedia*. But Savage will have to show that his character came first in time. Secondly, he will have to prove that Gervais' rendition of the character is a 'substantial copy' of his own (see Chapter 3, No Copyright in 'Ideas'?), or else seek a legal remedy in another technical part of the law (such as passing off or trade marks law), since copyright will not protect an 'idea' alone.

INFORMATION BANK

[1] This example is from Bonnington *et al.*, *Scots Law for Journalists*, (2000).

[2] There is some doubt on this point, and if you want to explore it further, you need to delve into the divergent judgments of the Law Lords in the leading case of *Designers Guild Ltd v Russell Williams (Textiles) Ltd* [2000] UKHL 58.

See also the following helpful resources from the Society of Authors', available free to members via its website, www.societyofauthors. org: *Guide to Your Copyrights After Your Death*, 2009; Robert Craig's *How to make life easier for your beneficiaries*, and, on the protection of characters, Nicola Solomon's *What a Character!* in *The Author* Spring 2001 (also available to members on the Society of Authors website).

3

No Copyright in 'Ideas'?

The basic position is that there is no copyright in ideas. The point is most clearly expressed in a 1937 case that I note below. However, it is not as simple as that. For literary works, it is not so easy to separate the form of expression from the ideas or concepts being expressed.

'Clothing the interview in expression'

The basic position simply stated can be found in *Donoghue* v *Allied Newspapers* [1938] Ch 106, which has been taken to have implications for ghostwriters.[1]

The case centred on a 1931 series of articles published in the *News of the World* about jockey Steve Donoghue (SD); SD was interviewed by 'Mr S T Felstead' (F), a reporter. F then wrote up the interviews in articles, some of which took the form of a dialogue with the jockey: i.e. potentially appearing to be transcripts of real conversations. SD had contracted to pre-approve the copy before it was published. SD sometimes suggested edits but these were not always made. Later F offered his articles to another publication (edited and updated) and negotiated a reuse fee for himself as writer. F asked permission for this reuse from both SD and the *News of the World*. The latter consented; SD did not, despite being offered a payment of £150/200. The second publication went ahead and SD sued for damages and applied for an injunction to prevent further publication. The High Court was pretty clear on this: SD argued that he had originated the material and therefore owned the copyright in it. The Court disagreed. On the contrary, under the then applicable 1911 Act:

Mr Justice Farwell said:

'... This at any rate is clear beyond all question, that there is no copyright in an idea, or in ideas. A person may have a brilliant idea for a story, or for a picture, or for a play, and one which appears to him to be original; but if he communicates that idea to an author

or an artist or a playwright, the production which is the result of the communication of the idea to the author or the artist or the playwright is the copyright of *the person who has clothed the idea in form*, whether by means of a picture, a play, or a book, and the owner of the idea has no rights in that product.

'On the other hand, and this I think is equally plain, if an author employs a shorthand writer to take down a story which the author is composing, word for word, in shorthand, and the shorthand writer then transcribes it, and the author has it published, the author is the owner of the copyright and not the shorthand writer. *A mere amanuensis does not, by taking down word for word the language of the author, become in any sense the owner of the copyright.* That is the property of the author.

'The explanation of that is this, that that in which copyright exists is the particular form of language by which the information which is conveyed is conveyed. If the idea, however original, is nothing more than an idea, and is not put into any form of words, or any form of expression, such as a picture, then there is no such thing as copyright at all. It is not until it is...reduced into writing or into some tangible form that there is any copyright, and the copyright exists in that particular form of language which...the information or the idea is conveyed to those who are intended to read it...'.[2]

So the judge felt that SD was not the copyright owner or part-copyright owner, albeit 'with some regret', since the articles were presented in such a way as to perhaps be leading the public into believing they were by SD himself. One modern ruling that echoes facts of that case concerns the Alan Clark spoof-diaries case and the law of false attribution and passing off (see Chapter 14, Moral Rights, Satire and Parody).

I mention *Donoghue* because of the judge's summary in his use of the phrase 'clothing the idea in form' strikes a chord.[3]

This point is explored further in the much more complex case of *The Da Vinci Code* (see Chapter 5).

Not quite as easy as that....

There is a very good article for lawyers by Justine Pila.[4] It tackles the idea/expression dichotomy, as lawyers refer to it, and suggests some reasons why it is not always easy to say that ideas are not copyright-protected, and copyright applies only to the expression of ideas and not to the ideas themselves.

For the purposes of this short book, I will just mention a few points she raises to give you a flavour. It is pretty technical stuff but interesting because it opens up opportunities for arguing the case in one way, or the other.

The trouble is that 'expression' and 'idea' overlap. Lord Hoffmann puts it best in the leading case of *Designers Guild* (see also Chapter 4, 'Substantial Part') when he says at paragraph 2422 of that judgment:

> 'every element in the expression of an artistic work (unless it got there by accident or compulsion) [is] the expression of an idea on the part of an author'

When it comes to writing, Lord Hoffmann accepted that you convey the idea itself in the way you say something, in the words or form you choose, in the expression of the idea. At times, formal expression/the fact and form of material fixation, and concept/idea blend necessarily. According to Pila's analysis of the cases on the subject, sometimes the courts will accept that language includes ideas (*Miller* v *Taylor* (1769) 4 Burr 2303, 98 ER 201 (KB)) and sometimes language is separated away from the ideas it conveys (*Donoghue* v *Allied Newspapers*).

The bottom line is that this is important because in looking at Work A and Work B, and in trying to apply the law to the situation, the courts will end up trying to dissect a work (a script, an article, a book) into its protectable and non-protectable parts. But to some at least, dividing works into conceptual and expressive stages (as required by the law) is artificial: *Ladbroke (Football) Ltd* v *William Hill (Football) Ltd* [1964] 1 WLR 273 (HL).

Again this is a slippery concept but have a think about this. To Pila:

> 'material form does not constitute the work, but rather is required to prove its existence'.

Or, to ask another question, should we focus on the expressed form to the exclusion of the idea or is the idea part of the expression? This issue arises in relation to speeches and records of proceedings etc. The cases are divided about whether there is sufficient independent skill in the act of a person taking down and reporting a speech to grant that transcriber/reporter copyright in

the expressed speech; or whether she is acting more in the role of a tool/a mechanical device – like a human tape recorder – and therefore should have no copyright, and that only the speaker should have copyright. (See further Chapter 13, Journalists and Newspaper Editors.)

As ever with copyright, when things get knotty like this it means that lawyers could argue the case one way or the other in court.

Implications

One of the implications for writers of the 'no copyright in ideas' rule is that a character per se may not attract copyright protection, and nor will a plot line (normally) or a television show format (see Chapter 8 and Chapter 16 for an exception in relation to characters and US law, which is different).

Never say 'never'

However, and you will read this a lot in this book, while the courts will *normally* not grant copyright exclusivity to ideas, plots, characters or concepts, they *might* do so, on specific occasions. Perhaps they will waive the general rule in favour of what they see as a more important overarching principle; or for another reason (e.g. a disinclination to be seen to condone criminal or underhand acts; or a dislike of Scientology or the publication of semi-naked photographs of underage girls). I am unsure about Lord Hoffmann's underlying feelings or principles, but certainly in his judgment in *Designers Guild* (see Chapter 4) His Lordship leaves things unclear when he said 'the original elements of a play or a novel may be a substantial part so that copyright may be infringed by a work which does not reproduce a single sentence of the original...'. Goodbye language copying...[5]

INFORMATION BANK

1 Bently and Sherman, *Intellectual Property Law* (2009) p.121.

2 This image of the 'mere amanuensis', for me at least, conjures up the spectre of Matt Lucas's character, Dame Sally Markham lying on her chaise dictating to her secretary (played by David Walliams) in *Little Britain!* On this subject see Chapter 13 on speeches and transcripts. And note the following, which is also interesting:
- on 'automatic writing': a spiritualist was found to be the 'author' of writings (*The Chronicle of Cleophas* concerning the acts and teaching of the Apostles), dictated to her 'from the grave' at a séance: *Cummins v Bond* [1927] 1 Ch 167.

3 'Judges hate Scientologists' said one of my expert consultants citing the older case of *Hubbard v Vosper* (Court of Appeal) 19 November 1971. In this case, the Court allowed Vosper and his publishers, Neville Spearman Ltd, to use 'substantial' extracts in his book *The Mind Benders*, allowing them to widen the 'criticism or review' exception for fair dealing in order to be able to say that Vosper was perfectly entitled to use the extracts for reasons of criticism or review of the doctrine or philosophy underlying Lafayette Ronald Hubbard's book – also known as Scientology. A double (or triple or quadruple?) negative to be found in *Vosper* is as follows: 'If copyright existed in *The Bible*, the use of extracts therefrom to attack Christianity or Judaism would not be covered by s.6(2) of [the old 1956 Copyright] Act': i.e. would not be exempted as fair dealing i.e. *would be* copyright-infringing. This seems to be flying in the face of all the reasoning noted above and elsewhere about copyright not being intended to protect wide ideas, only concepts expressed in a particular way – form not content. (Judges also love the Holy Grail: see Chapter 5, 'Substantial Copying' and *The Da Vinci Code*).

4 Justine Pila, *An International View of the Copyright Work* [2008] 71(4) MLR 535–58. In her article Pila is talking about all literary, dramatic, musical and artistic (LDMA) copyright works, not just literary works as I refer to them here.

5 Language copying is explained in Chapter 5.

4

'Substantial Part': Too close for comfort – quality not quantity

Yes you've copied, to some extent, or 'tributed'... or 'adapted'... but did you copy a 'substantial part' such that another writer could be entitled to start a copyright action against you?

There is much room for legal argument on this subject, so if you are 'copying', or in some way using another writer's work, you have to be able to explain why your work is a new, original (not copied) work, and has a separate copyright of its own.

Likewise, if you find someone else copying your work, there are ways in which you could argue that it is copyright-infringing: if you could convince the courts that your work came first in time; *and* that a 'substantial part' (s.16(3), 1988 Act) of your work – or the whole entire work – has been incorporated into the new work. The bottom line is that copyright law seeks to prevent one person appropriating the 'skill and labour' of another. But there are a lot of grey areas here, as the following discussion of the leading case, which concerned printed fabric designs, reveals.

Designers Guild case

In 2000, the House of Lords (now the Supreme Court) developed the current legal test to determine whether there has been an illegal/infringing copy. That test applies now.

In *Designers Guild* v *Russell Williams*, five Law Lords were asked to look at a previous decision of the Court of Appeal. In so doing they delivered five leading judgments that represent current law on copyright. Unfortunately for us, those judgments are not necessarily concurring – and not always complementary. In fact, at one point, there is flat contradiction (in my view), or at least circularity. So, the judgment needs to be treated with care and

allows for various different arguments to be run under it...
But in essence the ruling says:

1 Copyright law is different from the law of 'passing off'. If it were passing off, you could ask, 'did the creator of B copy A such that she would dupe onlookers into thinking B is A'? No, that is not the question for copyright (said the Lords).

2 If you do use copyright law, you look at the predecessor work, A: the thing that came first; and compare it with the second work, B: the thing that is alleged to be breaching the copyright of A. You need first of all to see the similarities, then you need to look at the works as a whole, and finally you need to decide if the work B has copied a substantial part of work A.

3 'substantial part' is a **qualitative** assessment – not **quantitative**. There is no need to show that a large percentage of the original design has been copied, rather that an important part or parts of the original design has been taken. The question of whether a 'substantial part' has been copied, said the Lords, should be answered by considering only the original design – *at this stage, there is no longer any reason to consider the copy design* and compare it with the original. So, anything you may have heard about being able to copy a certain percentage or number of elements of a work, you can forget. It's about quality: and the court will be the ultimate arbiter of that: not you, and not 'experts', although the court will usually consider expert evidence given on behalf of the parties.

Summarising *Designers Guild*

In essence what this case seems to mean is that
- **you can infringe copyright even if your work makes significant changes to the work it refers to.**

But, equally
- **you can still create a separate, new copyright work, even if you have copied some of another's work. And the new copyright work can be simultaneously infringing; or not.**

Circularity? Spanners in the works?

The following passages from the *Designers Guild* judgment give pause for thought. Read these later, after you have read the rest of this book: are we getting conflicting messages?

Plot can be a substantial part?

'... the original elements in the plot of a play or novel may be a substantial part, so that copyright may be infringed by a work which does not reproduce a single sentence of the original...'

Ideas vs expression problem

'...if one examines the cases in which the distinction between ideas and the expression of ideas has been given effect, I think it will be found that they support two quite distinct propositions. The first is that a copyright work may express certain ideas which are not protected because they have no connection with the literary, dramatic, musical, or artistic nature of the work. It is on this ground that, for example, a literary work which describes a system or invention does not entitle the author to claim protection for his system or invention as such. The same is true of an inventive concept expressed in an artistic work. However striking it may be, others are (in the absence of patent protection) free to express it in works of their own... the other proposition is that certain ideas expressed by a copyright work may not be protected because, although they are ideas of a literary, dramatic or artistic nature, they are not original, or so commonplace as to not form a substantial part of the work. ...'

Both quotes are from Lord Hoffmann's judgment in the House of Lords.

INFORMATION BANK

Designers Guild Ltd v *Russell Williams (Textiles) Ltd (t/a Washington DC)* (2000) WL 1720247, House of Lords, [2000] 1 WLR 2416; [2001] 1 All ER 700. For a fuller, illustrated discussion of this leading case, see Gillian Davies, *Essential Guide: Copyright Law for Artists, Designers and Photographers* (2010, A&C Black).

5

'Substantial Copying' and *The Da Vinci Code*

So, copyright is about preventing others from appropriating the product of your labour/riding off the back of your efforts without paying, and it is also *not* about ideas but about the expression of ideas: the writing itself. It is not permissible to lift the whole or a substantial part of an original copyright work without permission.

The leading case on what is meant by a 'substantial part' of the original predecessor work is *Designers Guild*, decided in the House of Lords in 2000 (see Chapter 4, 'Substantial Part': Too close for comfort).

Designers Guild was 'applied' by the Court of Appeal in *The Da Vinci Code* case (DVC), *Baigent v The Random House Group Ltd* [2006] (which means it was approved) and the general principles stated in *Designers Guild* 'applied' to the facts of DVC.

The DVC case is fascinating for many reasons, but it basically underlines the central concept that there is no copyright in ideas (or in that case, themes), only in the expression of those ideas; and that it is not lawful without permission to appropriate the 'literary labour' of others and use it as your own. That decision also seems to confirm that courts will find the general principle that there is 'no copyright in ideas' will hold more sway than the other general principle, that copyright is there to 'protect the sweat of the brow of others'. I shall explain.

Non-fiction to fiction I (*The Da Vinci Code*)	*Baigent v The Random House Group Ltd* [2006] Court of Appeal 28 March 2007 [2007], EWCA Civ 247.
	The case centres on Dan Brown's book, *The Da Vinci Code* (DVC), published in 2003, which two out of three of the co-authors of *The Holy Blood and the Holy Grail* (HBHG) – Michael Baigent and Richard Leigh – complained was in breach of their predecessor work, published in 1982. (Brown had faced, and defeated, a previous legal challenge in the US.)

Summary

Dan Brown's DVC did not infringe the copyright in HBHG because, although it was demonstrated that 11 out of 15 'themes' in HBHG had been 'taken' by Brown, and that those themes were the product of Baigent's and Leigh's research and labour, nevertheless copyright does not protect general or abstract themes or ideas or history, or information which is already 'out there'. In this case, the Court felt that the HBHG information was of that 'general' sort and was not capable of being ring-fenced by copyright. Brown was therefore entitled to 'copy' to the extent that he did (and admitted to). His acknowledgement of HBHG both directly, in the form of an acknowledgement, and indirectly, in the form of a nod to the HBHG authors in the plot, in the naming of a character, and in the presence of the HBHG book in a 'cameo role' in his novel, all seemed helpful to Brown in his defence. Brown would have had to have done something more to infringe copyright, something along the lines of the language and textual 'copying' which were found to be fateful in the previous case of *Ravenscroft* v *Herbert*.

HBHG is a non-fiction work – a 'work of historical conjecture' (Anna Caddick) – albeit flawed in the eyes of some critics because it was based on 'not historically correct' research techniques. Very broadly stated, it posits a thesis about Jesus marrying Mary of Magdalene, having children, and their descendents being still alive due to the passing on of 'the bloodline' via the French monarchy. Exactly what it covers is the subject of a lot of evidence and analysis in the lengthy judgments. A key idea is that the Holy Grail is not an artefact or a theory but a person: the Mary Magdalene. HBHG could also be seen as a sequel to television programmes and films on the same story which preceded it. (There is a long line of works on the subject, ranging from works earlier than HBHG as well as the prequel to DVC, *Angels & Demons*, published in 2009).

DVC is a present-day fictional thriller based on facts. The hero is trying to gather evidence to prove that the above storyline is true.

Random House was the publisher of both books (following various publishing mergers) but was the defendant in the case as publisher of DVC by virtue of having allegedly 'authorised the reproduction of a substantial part of the copyright in HBHG'.

It was established as fact that Brown had access to the earlier work, but Brown argued that his wife, Blythe Brown, had read

HBHG as *one of several sources* and had been less influenced by it than by other sources. Brown accepted that he had seen HBHG and borrowed some aspects of it, and acknowledged the source (one character in DVC is called 'Leigh Teabing', an anagram of Baigent + Leigh).

The acknowledgement

'... it may be observed that in writing the Langdon/Teabing lectures Mr Brown has acknowledged the use of HBHG as a source for the lectures' ideas in HBHG both cryptically, since Leigh Teabing is an anagram of Messrs Baigent and Leigh, and straightforwardly, when he has Teabing show HBHG to Sophie, describing it as "perhaps the best-known tome" on the subject and recording its claim to be "The Acclaimed International Bestseller". That is not the mark of an author who thought that he was making illegitimate use of the fruits of someone else's literary labours, but of one who intended to acknowledge a debt of ideas, which he has gone on to express in his own way and for his own purposes.' Lloyd J, summing up in the Court of Appeal at paragraph 286.

.............................

** Note that in my reading of the case there seems to have been some confusion about the 'central theme' and whether it needs to be a substantial part of HBHG or of DVC for the legal arguments. Under the leading case of *Designers Guild* (see Chapter 4, 'Substantial Part': Too close for comfort) the test should be that the central theme would have had to have been a substantial part of HBHG. This gets confused in the DVC judgement.

The Court of Appeal found that Brown did not appropriate the skill and labour of B&L because the central themes which he used (the Court accepted that 11 of the 15 themes, across six chapters of DVC were in common) were nevertheless not copyright-infringing because there can be no copyright in general themes and ideas. The central theme (of HBHG)** was not a 'literary work' protected by copyright (trial judge at paragraph 245).

'Sweat of the brow'

The central theme: Baigent and Leigh's argument was that in their research, and in creating HBHG, they had made a sequence of connections that no one had made before, drawing on expertise in a number of diverse areas, and that for the first time they had expressed a continuous linkage through history – and this is what Brown unlawfully copied. This is the argument that ultimately failed: the Court of Appeal judges agreed – in a roundabout way with the High Court judge who they nevertheless roundly criticised – that even if Brown did 'steal' the 'central theme', it did not form a 'substantial part' of HBHG, and so was not protected as an original copyright work.

The case is fascinating for various reasons:

1 It proves that you should never employ your spouse in the capacity of researcher! (I am joking but was quite amused by the fact that Dan Brown did not do the research that was at the crux of this case, but his wife did...).

2 Court judgments make no sense at all, this one especially (again this is a flippant remark intended to amuse, but it is also serious: the Court of Appeal itself criticised the trial judge, saying that his ruling was so confusing as to enable both sides in the litigation on completion of the hearing to be able to read it as going in their favour!

3 It offers both three-stage and six-stage tests (see p.30) on whether there has been copyright infringement.

4 It applies *Designers Guild* to the literary copyright field to determine:

- when something will be an infringing copy of a 'substantial part' of an original; and also
- when the 'substantial part' test kicks in – at what stage in the consideration of the facts.

5 It makes incidental points of note relevant to *abstracts/précis* (in so-called '*obiter*' remarks).

No copyright in ideas

The case re-emphasises that there can be no copyright infringement where all that is copied are ideas or, as in this case, general themes. The 'story' of the Holy Grail and the merging of Jesus' bloodline with the Merovingian bloodline, is 'out there' in the common domain – see, for example, www.priory-of-sion.com.

But this law on copyright is now pretty well accepted (see Chapter 3, No Copyright in 'Ideas'?): so why was it even argued? I am bamboozled by the sheer weight of evidence – the detail – presented at both trials, describing the 'central themes', since this is supposed to be a red herring under copyright principles (there is no copyright in abstract ideas). Surely the claimants' attempt to rely on non-textual elements – themes – was completely wrong for a copyright trial? Why do we have pages and pages of detail in both the trial judgment and the appeal case, analysing and identifying the central theme (comprising 15 themes) that was alleged to have been stolen from HBHG?

The reason – I think! – has something to do with the 'substantial part' point *viz.* the more complex, intricate and detailed work A is in its ideas, plot, themes, premises – all the things that copyright

protection is not meant to attach to – the more likely it is to be deemed to be a copyright original in itself – the first stage in proving a copyright infringement:

- For 'the copying of a substantial part to amount to an infringement of copyright, the material copied had to lie on the right side of the line between ideas and expression.' (the Court of Appeal agrees with the trial judge on that).
- 'Generally speaking, in cases of artistic copyright, the more abstract and simple the copied idea, the less likely it is to constitute a substantial part. Originality, in the sense of the contribution of the author's skill and labour, tends to lie in the detail with which the basic idea is presented.' Lord Hoffmann in the *Designers Guild* case.

This seems to mean that although **usually** there is no copyright in ideas/general themes etc., should those ideas/general themes become intricate enough, they **may** be afforded copyright protection. But this makes it difficult to decide whether that part of the judgment clarifies things or adds more confusion. It is probably the part of the judgment we should ignore, concentrating instead on the less ambiguous parts which consider there to have been clear borrowing – but borrowing of elements that it is permissible to borrow.

When does the 'substantial part' test kick in?

1 *Access*: 'If material is found in a later work which is also in an earlier copyright work, and it is shown that the author of the later work had access to the earlier work, an inference of copying is raised.'
2 *Alternative explanation*: 'Then it has to be considered whether there was in fact any copying, in relation to which the later author may say that he obtained the material from his own unaided efforts or from a different source.' (Looking at the whole of work B.)
3 *Substantial part*: 'If it is found that any of the material common to both works was copied from the earlier work, then the question arises whether what was copied was a substantial part of the earlier work'. Most of this is fact-finding and the business of the trial court not a Court of Appeal (looking at work A).

Or, expressed another way:
1 inference of copying (onus on claimant);

2 defendant rebuffs copying claim;

3 onus on claimant again.

Trial judge errors?

According to Mr Justice Lloyd in the Court of Appeal, the original judge (Mr Justice Peter Smith), was hasty in publishing his 70-page judgment, which he produced within three weeks of the hearing; he even included a coded message in his judgment – inspired by DVC: 'the judgment is not easy to read or to understand', says Mr Justice Lloyd, 'It might have been preferable for him to have allowed himself more time for the preparation, checking and revision of the judgment.'

The Court also referred to the case of *Ravenscroft* v *Herbert*, where there had been wholesale pillaging of a single theme plus incident and 'deliberate language copying' – thereby leading James Herbert to be in breach of Ravenscroft's copyright (see also Chapter 6, 'Substantial Copying' and the *Spear of Destiny* Case) and to *Christoffer* v *Poseidon*, a case involving a children's animated cartoon, where there had been copying of specific incidents.

Mr Justice Mummery: the six-stage test on substantial copying (from DVC)

(1) What are the similarities between the alleged infringing work and the original copyright work? Unless similarities exist, there is no arguable case of copying, and an allegation of infringement should never get as far as legal proceedings, let alone a trial. The 1988 Act confers on the owner the exclusive right 'to copy the work' either directly or indirectly (s.16). **This is not an exclusive right to prevent the publication of a work on a similar subject, or a work which happens to contain similar material, thematic or otherwise**.

(2) What access, direct or indirect, did the author of the alleged infringing work have to the original copyright work? Unless there was some evidence from which access can be directly proved or properly inferred, it will not be possible to establish a causal connection between the two works, which is essential if the claimants are to prove that the defendant's work is a copy.

(3) Did the author of the alleged infringing work make some use in his work of material derived by him, directly or indirectly, from the original work?

(4) If the defendant contends that no such use was made, what is his explanation for the similarities between the alleged infringing work and the original copyright work? Are they, for example, coincidental? Or are they explained by the use of similar sources? If the latter, what are the common sources which explain the similarities? How were the sources used by the authors of the respective works?

(5) If, however, use was made of the original copyright work in producing the alleged infringing work, did it amount, in all the circumstances, to 'a substantial part' of the original work? The acts restricted by the copyright in a literary work are to the doing of them 'in relation to the work as a whole or any substantial part of it'. See s.16(3)(b) of the 1988 Act.

(6) What are the circumstances or factors which justify evaluating the part copied in the alleged infringing work as 'a substantial part' of the original copyright work?

Comment by Anna Caddick

Baigent and Leigh lost the case, but don't forget that (according to Caddick) 'the half-forgotten victory for the claimants [B&L]... was the fact that Brown was found by the Court to have lied and to have copied the central chapters for DVC from HBHG. That is worth a moment's reflection. Without HBHG there would have been no DVC and no spin-off film... DVC might not have taken a substantial part of HBHG, but the ideas copied formed a substantial part of DVC [but that is not the legal test so the case failed]. ...The defendants profited substantially from someone else's work. But that is the price of having a copyright law that promotes rather than stifles creativity'.

Do you agree?

INFORMATION BANK

Anna Caddick, *New Law Journal* vol 157 (2007) p.758–9 (interpretation of DVC case as being 'pro-creativity and the public domain'). 'Even if there is sufficient material upon which it can be concluded that a defendant has copied from a claimant's work, it does not follow that a court will conclude that a substantial part has been taken.' (Mr Justice Peter Smith did find copying, but not copying of a 'substantial part' of HBHG).

6

Substantial Copying: *The Spear of Destiny* case

Ravenscroft v James Herbert and the New English Library Limited

This case involves the alleged infringement of copyright by James Herbert (JH) in his 1978 'horror comic' (or fictional thriller), *The Spear*, of Trevor Ravenscroft's (R) 1972 historical/'mystic' offering, *The Spear of Destiny*. JH was found by the Chancery Court (a division of the High Court) to be in breach of a substantial part of R's work, and had to surrender unbound pages of parts of the unpublished *The Spear* (the bits with the infringing prologues) and pay 90 per cent of R's costs.

The ruling is much more straightforward and clearer than *The Da Vinci Code* case (DVC), and you can understand why the Court of Appeal reverted to the logic of that earlier ruling:

Mr Justice Brightman in *R* v *JH* concluded that

'... I have no shadow of doubt that [JH] has copied from *The Spear of Destiny* to a substantial extent. In the prologues ... he has deliberately copied the language of [R] on many occasions. To a more significant extent he has adopted wholesale the identical incidents of documented and occult history which [R] used in support of his theory of the ancestry and attributes of the spear, of Hitler's obsession with it and also General Patton's. He did this in order to give his novel a backbone of truth with the least possible labour to himself. In so doing he annexed for his own purposes the skill and labour of [R] to an extent which is not permissible under the law of copyright. [JH] has clearly infringed [R's] copyright.'

This in spite of the fact that:

'I am satisfied that [JH] did not intend to injure [R] and did not appreciate that he was doing so'.

The prologues

Herbert was found to have interspersed his 23-chapter novel with seven 'historical' prologues, which were to set a 'backcloth of apparent truth' to his fictional story. It is these which were found to be in breach of a substantial part of R's work: five out of the seven being so close in language, incident and description as to be in breach of R's work.

On a legal basis the case was decided by looking at a four-part test of copying which that court felt appropriate under the then-applicable 1956 Copyright Act.

On a non-legal basis it seems relevant that the judge held the populist aspects of Herbert's novel in low regard (describing this book as 'racy' 'rubbish', and 'with a lot of violence for the sake of violence').

Another important aspect of the case is the role of the acknowledgement that Herbert made in his book, but which nevertheless was found to be copyright-infringing.

The acknowledgement

The 'Author's Note' at the end of the book included this sentence:

> 'The idea for this book came from Trevor Ravenscroft's extra-ordinary *The Spear of Destiny*, a detailed (and unsettling) study of Adolf Hitler's association with the Heilige Lance'.

Herbert admitted himself in relation to language copying that: 'it would have been very easy for me to have disguised all this, but there was no reason to'.

But this did not prevent a ruling of illicit substantial copying. However, what the acknowledgement DID seem to do is mitigate damages – the Court refused to see Herbert's copying as being 'flagrant'.

The role of desk and copy-editors

The acknowledgement also affected the liability of the publisher, New English Library Limited: the court felt that since the author had included this note it effectively put the publisher on notice that there could be copyright issues. The publisher offered no evidence to suggest that it had done anything to check the copyright position, or clear any permissions, and was found liable as well. (No publishing staff gave testimony.) They should have

presented evidence in court in order to establish a defence of innocent dissemination.

NB: the publisher thought it was following correct copyright procedure because it based its decisions on the copyright provisions of a guide by the Publishers Association: this did not stand up in court.

Historical works treated differently from novels

This case also suggests that the courts will look differently for the purposes of copyright law at historical works as opposed to works of fiction: the basic point being that writers of history are building up a body of research, and are free to use previous historical research to inform their own work which, if properly executed, should take the 'history' a step further. The information contained in 'histories' is therefore less ring-fenced in copyright terms – will be held to be of a lower standard of originality – or to put it another way – be more in the public domain – and therefore be afforded less strict protections than the more 'original' creative efforts of, say, a novelist. This is because there can be no monopoly on facts: for example the court did not want to 'monopolise' the 11 character names that JH took from R, or his descriptions of the spear (based on an actual artefact, the Hofburg Spear in Vienna) and its mode of display.

There may be more freedom to copy in the case of the historical work:

'...it seems to me reasonable to suppose that the law of copyright will allow a wider use to be made of a historical work than of a novel so that knowledge can be built upon knowledge'.

It did not seem to matter that Ravenscroft's work was accepted by the court to be 'bad history' or, rather, a selection from history:

'... disjointed and unmethodical (no offensive criticism is intended of the literary technique ...) ... composed of a variety of different events, recollections, quotations, philosophy, meditations and so on, designed to support the theory in which [R] had come to believe. Vast areas of history are left out [by R] in his attempt to persuade the reader that the Hofburg Spear has the ancestry and attributes which [R] believes are to be ascribed to it. The book is a very personal insight into history ...'.

Quality not quantity

Although in numeric terms the prologues were found to be only 4 per cent of JH's work, in qualitative terms they were found to be more important, and so the court placed a nominal percentage of 15 per cent on them when assessing damages.

News scoops not protected for the information they relate

Springfield v *Thame* (1903)

In this case the claimant had written an article that described in 83 lines the narrow escape from drowning of a distinguished eye specialist. He sent copies of the piece to the *Daily Mail* and to the *Evening Standard*. The *Daily Mail* accepted the article, paid the claimant for it and published a sub-edited version that was condensed into 18 lines. The *Evening Standard*, without the licence of the claimant, then published the same paragraph with slight alternations.

Mr Justice Joyce said this *obiter*:

'In my opinion, if the original composition had been accepted and published *verbatim et litteratim* in the *Daily Mail*, the paragraph in the *Evening Standard* would still have been no infringement of the copyright in the original composition, since there is no copyright in news, but only in the manner of expressing it.

'I do not think that much can be read into this case for present purposes. It proceeded upon the basis that Mr Springfield had no monopoly in the facts of the escape and was not entitled under the law of copyright to any protection for his skill and labour (if any) in researching such facts. The learned judge found that the offending paragraph was in truth and in substance a different statement of the facts contained in the original composition.

'In my judgement, Mr Laddie's proposition must not be pressed too far. It is, I think, clear from the authorities that an author is not entitled, under the guise of producing an original work, to reproduce the arguments and illustrations of another author so as to appropriate to himself the literary labours of that author...'.

7

Quoting/Extracts

Copyright law rests upon some very slippery concepts,[1] and so you will not be surprised when I say that there is no direct, easy answer to the linked questions: 'can I quote from another work, and if so how much text is it permissible to use?'[2]

The music industry has some rules of thumb. For example, on sampling, there is the '30-second rule' whereby you can buy a Mechanical-Copyright Protection Society (MCPS) licence to use a clip of music of up to 30 seconds in audio-visual footage for a certain fee (this covers a one- to 29-second clip). However, higher fees apply to clips of 30 seconds and over.

But there are really no such 'rules', no scientific measure, for literary copyright. No wordcount or recipe.

That said, the Society of Authors has a guidance note (prepared jointly with the Association of Authors' Agents and the Publishers Association (PA) which may be read as a sort of industry standard as to the practical application of what may be defended as 'fair dealing'. However, please note that this is not based on any Act of Parliament, and was discredited in court (in the case of *Ravenscroft* v *Herbert*: see Chapter 6, 'Substantial Copying' and the *Spear of Destiny* case). The Society of Authors itself also warns that the guidance could be in breach of EU anti-competition laws.

The broad principle: 'substantial part'

Any copying will fall on the wrong side of the law if the copier unlawfully adopts another's original work, depriving the original creator of the opportunity to earn income from it. The courts will look at the quality of the work taken, not the quantity, on this question. (Please note there may be a slight difference of approach here *vis a vis* quality v quantity in the context of substantial copying when compared with other parts of copyright law, for example the defence of fair dealing for current affairs news reporting. See Chapters 9, 'Criticism or Review' and 'Incidental Inclusion' and 13, Journalists and Newspaper Editors.)

There is no hard and fast rule, so you can forget anything you have heard in relation to percentages. Deciding whether what you have taken would amount to a 'substantial part' of another work (and therefore infringe its copyright) is about *quality* not quantity (*Designers Guild*, see Chapter 4, 'Substantial Part': Too close for comfort). You could therefore reproduce a chunk of a novel in another publication or film, for example, without the permission of the copyright owner without being in breach of the original author's copyright. Or, in theory, you could reproduce just one word or phrase from a work and find yourself in breach of the original author's copyright because that word or phrase was key (e.g. the last page of a Whodunit; a single ingredient in a recipe; a distinctive word in a short poem; or perhaps a Table[3] summarising important information). Please remember that we are talking about a 'substantial part' of the *thing allegedly copied*; not of the later work.

Cases mentioned elsewhere in this book reveal the following figures and proportions which are interesting but, because of what I have explained above, should not be seen as comprehensive or binding guides:

- In the *Paddy Ashdown* case (see Chapter 13), the fact that the defendant newspaper used approximately one-fifth of PA's Minute, in what amounted to approximately one-quarter of the main article, was fatal to the newspaper's defence (it lost the case).
- In the *The Da Vinci Code* case, 11 of the 15 'central themes' had been copied; but ultimately it was decided by the Court of Appeal that this was an artificial device set up in evidence by the defendant publisher and so not that relevant to an analysis of copyright law issues. So, Dan Brown's use of the 11 themes did not stop him ultimately winning the case on appeal.
- On the other hand, in *Ravenscroft* v *James Herbert*, Herbert's copying of Ravenscroft's work in five out of seven of his prologues was very damaging to Herbert.
- In *Infopaq* v *Danske Dagblades* Case C-5/08, the European Court of Justice said that the data capture by automated means of 11 words from online news articles could be copyright infringing.[4]

You can quote without permission with impunity:

- *If* all the parties who have copyright title have granted you permission (please note that this could mean one person or several) but get it in writing, just in case.

- *If* the work is in the public domain, i.e. 70 years have passed since the author's death and the text is no longer in copyright. However, note complications raised by revived copyright (see Arthur Conan Doyle example, Chapter 8); reversionary rights and unpublished works (see Table 15.2, p.111).
- *If* you can rely on fair dealing (for current affairs news reporting; private study or research; criticism or review; or 'instructional' or 'examination' use for unpublished works, with acknowledgement).
- *If* you can say your use is an example of 'incidental inclusion' (see Chapters 9, 'Criticism or Review' and 'Incidental Inclusion' and 16, Other Very Interesting Bits and Bobs).

In practice

Don't forget – and I cannot repeat this too many times – the point about copyright law is that you are supposed to ask for permission to use something that someone else created first. But guess what? Once you have asked the question you sometimes get a straight answer 'yes that's ok' and it is sometimes free, and the job is done! It does happen!

Equally, you often get no reply at all. And no reply means no permission has been granted: silence does not equal consent.

Specific considerations

Once you understand the general principle above, even if it is none too helpful, you may go on to the specific questions which apply when deciding if you need copyright permission to reproduce an extract.

1 Which country's laws apply?
2 Is it in copyright in the first place?
3 Is it published?
4 Can the use be defended as fair dealing or as a *de minimis* exception?

1. Which country's laws apply?

Works by non-European authors: Where are your readers? If you are selling a paperback into Japan then Japanese copyright laws will apply. If you are selling an ebook which can be downloaded by Egyptians, the laws of Egyptian copyright will apply. Note that this is different to libel law because if you publish a statement

online, you could be caught by the libel laws of every country that the information reaches.

2. Is it in copyright?

This is to do with 'term' (duration) of copyright, because as a matter of principle copyright was not intended to last forever: the lawmakers felt that to 'monopolise' works in perpetuity would be going too far. So, the usual rule is that a work remains in copyright for the lifetime of the author plus 70 years after the end of the year in which she died (lifetime of the author *post mortem auctores*: PMA).

But there are a lot of exceptions to this: see Table 15.2 (p.111).

Letters enjoy the same copyright protection as other literary works. However, the recipient of the letter owns the physical letter itself, but the writer, or the writer's estate, might own copyright in the letter's contents (see Chapter 1, Introduction, explaining the difference between real and intellectual property and the *Jefferys* v *Boosey* case). That said, some experts think that if you send a letter to someone (e.g. a newspaper editor) you are granting that person an implied licence to use it/publish it.

Works which are copyright in other countries may be protected for different periods, though for use in the UK, that period may not be longer than 70 years PMA ss.5.

3. Is it published?

For published works see above (2. Is it in copyright?).

For unpublished works: copyright arises the minute a work is expressed. That can mean 'expressed' in the form of being written as a manuscript (or typescript), so 'publication' in the industry sense of being printed and distributed by a publishing house is not required. Manuscripts are protected by copyright. The copyright is the author's until she decides to pass copyright on, or license, her work (as is the usual mechanism on signing a publishing contract).

So, to obtain permission to use an unpublished work, ask the author. Be aware that you cannot, or are unlikely to be able to, rely on the exception for fair dealing when quoting from unpublished material: see *Paddy Ashdown* case discussed in Chapter 13, Journalists and Newspaper Editors.

Deceased authors

For unpublished works, where the author died *before* 1 August 1989, any works (other than artistic works) which were unpublished at the time of his or her death will remain in copyright until 50 years from the end of the calendar year in which it was made available to the public, or up to 1 January 2040, whichever is sooner. If 70 years PMA is longer than that period, the 70 years PMA rule will prevail, but not otherwise.

Where the author died *after* 1 August 1989, works not published during the author's lifetime remain in copyright for 70 years PMA. Whether or not the material is published or made available to the public during those 70 years is irrelevant to the term of copyright (likewise for artistic works).

There are special rules covering old unpublished works, including letters kept in libraries, museums or other institutions, where they are open to public inspection. They apply in cases where: (i) more than 50 years have elapsed since the end of the calendar year in which the author died; and (ii) more than 100 years have elapsed since 'the time, or the end of the period, at or during which the work was made'.

4. Is it fair dealing?

The Society of Authors' rough rule is:

> 'it will usually be regarded as "fair dealing" to use a single extract of up to 400 words or a series of extracts (of which none exceeds 300 words) to a total of 800 words from a prose work; or extracts to a total of 40 lines from a poem, provided that this does not exceed a quarter of the poem. ... the quotation must be for **criticism or review** of that or another work. While this statement does not have the force of law, it carried considerable weight with a judge experienced in copyright in a leading infringement case. It does not mean, however, that a quotation "for purposes of criticism or review" in excess of these limits cannot rank as "fair dealing" in some circumstances.'

Note especially that 'fair dealing' for the purposes of 'criticism or review' means 'criticism or review' of the literary work, document, or letter in question. And so here, for example, where I am quoting passages or lyrics or film scripts as exemplars, and I am not actually criticising the film, novel, or the letter itself, I would not feel confident that the courts would accept that this was fair

dealing. As a result I would ask for permission to copy or quote or reproduce.

If it is not 'fair dealing', the Society of Authors *used to* suggest the following ballpark figures (in its Estates Departments Rates 2009), in relation to the copyright owners it represents for re-use:

- Brief illustrative quotations outside the scope of fair dealing will normally be granted permission without charge.
- Fees will normally be charged for quotations **of any length** in an anthology; usually a minimum of £50.
- *Prose*: £170 for 1,000 words; plus an additional 50 per cent if a whole chapter or whole short story is reproduced; rates may be reduced if the use is of a critical or scholarly work with a print run under 1,500 copies.
- *Poetry*: £140 for the first ten lines; £2.70 per line thereafter for the next 20 lines; £1.75 per line thereafter. Rates reduced in similar circumstances as above.
- Those rates apply to world English-language rights; reduced rates apply to more restricted markets.

Note, however, that as well as being historical, those figures 'are our own internal rates that we use for the literary estates represented by the Society. All copyright owners are entitled to levy permission fees at their discretion'. They are reproduced here, however, because this is a form of industry standard and, as such, the courts might be influenced by them if the issues went to trial.

On de minimis,[5] see p.123.

Lyrics

The music industry is notorious for protecting its copyright owners much more fiercely than any other creative sector. Cynically, this is because in the music industry the copyright owners are not the 'little fish' but the 'big cheeses'. According to King Crimson founder member, and legendary guitarist, Robert Fripp:

'I tend to the view that musical copyright is a somewhat different area [to literary copyright]. Probably 99 per cent of all composed and recorded European music in the 20th century is owned by a small number of large corporations. This gives them a great deal of lobbying power. I doubt that book publishing houses have quite the same degree of capital interest.'

Given this muscle power, it should come as no surprise that the use of lyrics can be unusually expensive: see the article by Blake Morrison in *The Guardian* on 1 May 2010 on the cost of quoting lyrics: 'I still have the invoices. For quoting one line of "Jumpin' Jack Flash": £500. For one line of "Wonderwall": £535'.[6]

Case Study: Pink lyrics

'Guess I just lost my husband, I don't know where he went'

'So What' *Words and Music by Max Martin, Alecia Moore and Johan Schuster © Copyright 2008 Pink Inside Publishing/ Maratone, AB. EMI Music Publishing Limited, London W8 5SW (33.33%)/Kobalt Music Publishing Limited (66.67%). All Rights Reserved. International Copyright Secured. Used by permission of Music Sales Limited and EMI Publishing Limited.*

You might recognise the quote above. It is part of a Pink track, 'So What', from her *Funhouse* album. Since it took over four months of negotiation to agree the cost of printing those 12 words, it has become another case study. The negotiations were protracted, mainly because of the number of parties involved; an element of 'chicken and egg'; and confusion over the Most Favoured Nation (MFN) rule (see below), but we got there in the end. I am not sure how this can possibly ever fit into the publishing schedule of a daily newspaper, or any publication with urgent deadlines. I was assured (but not reassured) by the music licensor agents I consulted that they can 'fast track' some requests if needed, but they are basically under an obligation to clear the permission with all the copyright owners: which for music can mean several parties, so you should make sure you have plenty of time in hand.

To include a line of song lyrics in a publication you first need to establish who the copyright owner is or are. A first step is to look at the current music publishers via the Mechanical Copyright Protection Society and Performing Rights Society (MCPS-PRS) or Music Publishers Association (MPA). MPA member details are available online,[7] if you already know who the track's music publishers are. There are no standard fees or procedures. Each copyright owner will apply different charges. However, Music Sales Limited (MSL) administers the copyrights for a large amount of music, plus certain rights on behalf of others and so, again, can be a helpful first port of call.[8]

In this case copyright in the lyric is owned by two publishers:

- 66.67 per cent managed by Kobalt Music Publishing Limited, administered non-exclusively by MSL, and
- 33.33 per cent share managed by EMI Music Publishing.

The 33.33 per cent share: my query bounced around for a while. MPA first directed me to Faber Music Ltd which acts for EMI on sheet music publications and print. Faber passed the baton back to 'EMI Music Publishing Ltd'. We negotiated a licence for a sum I cannot disclose, but it looked like being one-tenth of the permissions budget for the whole of this book for their share only. (I am contractually not permitted to quote the exact sums of money involved under the licence signed to secure the words quoted above.) This was a mistake. I was confused at first because the figure quoted was based on an entitlement to 100 per cent of the fee, so looked much more expensive than it really was. The actual licence fee was for one-third of that sum. But that was not the end of the story.

The 66.67 per cent share: MSL could not tell me how much it would cost to use the line until I could tell them, on behalf of the copyright owners, where the quote would be used, including details of the publication, the ISBN and the intended market (print run; countries sold into and so on). As a freelance author I did not have this information at the research stage. And to make matters worse, MSL also wanted to see the line in context: i.e. it wanted a page proof. Well, this was chicken-and-egg territory since I was still working on the first draft. I did not know if the line was going in or not because until I knew how much it would cost, I could not decide how best to spend the (small) rights budget available to me (this situation also arose in picture research in my book, Copyright Law for Artists, Photographers and Designers, see Chapter 11, Defences I: Matisse case study [London: A&C Black, 2010]).

I explained why sending a page proof was impossible, and the Third Party Licensing Department of MSL gave me a ballpark estimate, which changed as we got into things. I have to admit to some confusion here because again I thought MSL were talking about their total licence fee. They were not. They were only quoting two-thirds of the total sum plus VAT.

So why the fluctuations in quoted fees? The first change was due to us, the publisher, asking for wider rights (adding on

a request for ebooks). The second increase was because I then agreed in principle to go ahead with the quote with the two rightsholders and attached a draft chapter to let them both see the lyric as quoted in context. At that stage one licensor saw that the other's was higher than its rate and so increased its prices invoking its MFN clause.

The MFN clause:

> 'in the event that you agree more favourable terms with any third party contributors of compositions to the Publication you shall promptly inform us in writing and our fee and terms shall automatically be amended to equal the most favourable'.

BUT, after submitting this typescript to the publisher, MSL belatedly contacted me to say that it was not in fact able to act on behalf of Kobalt, and that Kobalt needed to do it themselves (although this was unusual), so the permission request was delayed further. EMI said that it would be a pity not to use the lyric so, if Kobalt agreed, it would drop back down to a licence fee at the level agreed, with each licensor collecting their respective percentages. Even submitting this text to the publisher a second time, post copy date, I still did not have Kobalt's permission and all the parties involved in this query were getting very weary and grumpy. A complete saga, in fact. But, eventually we got there, with MSL granting permission at an agreed rate.

So, the music industry is good at collecting all possible copyright revenues on behalf of its copyright owners, as it is experienced at licensing usages; but this can be an expensive, confusing, and time-consuming process. But at least they did not ignore my emails and we know where we all stand (probably in a position where I cannot afford to use a lyric!).

Lesson learned

It is industry practice for licence holders to quote permissions fees on a 100 per cent basis, even if the licensor in question only holds a percentage: so don't, like me, get confused! If Licensor A says the fee is £50 plus VAT based on a 100 per cent share; and Licensor B says the fee is £50 plus VAT then you pay £50 plus VAT total. But because of the MFN principle, if Licensor A says £50 plus VAT based on 100 per cent share, and Licensor B says £60 plus VAT based on 100 per cent share, you will pay £60 plus VAT (unless

you can negotiate otherwise, as above). You would be forgiven for thinking that when dealing with more than one rightsholder, the best thing to do would be not to disclose how much you are paying each party, and to keep communications separate: because if they see each others' 'confidential' fees rates and one spots that the other is quoting a higher rate, they will raise their price to match the higher fee. Legally, however, the situation may be that in signing a licence with a partial rightsholder, you will be agreeing to disclose the higher fee to all other rightsholders and keeping 'secrets' may not be possible.

The final cost of printing those 12 words? I am not allowed to say, but it did end up being more than one-tenth of the permissions budget for the entire book. At one stage it looked like being around a quarter of the budget, but that was due to me doubling up on the MFN confusion. The process would have been similar for a quote from another Pink song, 'Sober', except that there are four rightsholders for that song: Music Sales Limited on behalf of Kobalt (5 per cent), EMI (33.34 per cent); Warner/Chappell (28.32 per cent); and Bug Music Ltd (33.34 per cent). Following my experience, this sounds intimidating, but I am told (by the music licensing agents) that my situation here was very unusual and that 90 per cent of all lyric requests are much more straightforward...

Health warnings

1 Don't necessarily expect an answer. Many recipients of copyright queries find the question annoying; you will often hit a wall of silence or irritation because the query will have arrived on the desk of someone who has other things to do. Few publishers have 'copyright compliance officers', and what with rapid staff turnover levels for editors, it is hardly surprising that records are not kept or handed over. Film4 provided me with a good example here: a senior legal adviser called me on the telephone to let me know that 'he couldn't see there being a problem' if I used a quote from a certain film, but that I should contact the film producer just in case he had any issues. I tried to but got no reply. The Film4 informal (verbal) consent will not go very far in court, in the highly unlikely situation we get into a legal dispute over this, but at least I feel safer. And, if push comes to shove, I can at least show that I have made real efforts to ask for permission.

2 If you are lucky enough to get an answer it may take the form of another question; or a suggestion that you get in touch with another contact. If you love paper trails and have heaps of time and patience, copyright clearance is for you.

3 Alternatively, if you are lucky enough to get an answer, it may be wrong. In my last copyright book, we obtained permission to reproduce a photograph, but then on going back to double-check contacted a senior staff member who overturned the original decision. They said 'we've granted you permission but actually we can't because we don't have the correct licence ourselves so cannot sub-licence'.

4 UK law and US law are different from each other. And national laws throughout the EU and the rest of the world differ from country to country too – as do their legal systems and judicial procedures. So, you need to explain the territory of your publication (where will your readers/buyers be) and clear copyright in every single individual country. And if you are online, that means the world.

5 And if you get no answer? It is a question of how much risk you perceive. Is another creator or rights owner going to object to your use of her copyright work? As a last-ditch attempt you could follow up any written request with another letter, sent by Recorded or Special Delivery with a cover note saying that if you hear nothing by a given deadline you will assume that there is no objection to the use you describe. But, as noted earlier, silence is not consent or deemed consent.

'Fair dealing' for research and private study

If you are writing for yourself (say a PhD thesis) you do not need to ask permission; but you do have to acknowledge the source (unless an acknowledgement would be 'impossible for reasons of practicality or otherwise' says s.29(1B) of the 1988 Act, woollily).[9] But if you are writing a book, article or news item which will be published – in print – by a commercial publisher, you are clearly going to reap economic rewards for your efforts. One of the main principles of copyright is to prevent you from using the work of others to make money for yourself: even if it is not a lot of money. Of course, you could ask permission and get it and pay nothing, but you do have to ask yourself if there is a 'commercial purpose' to your work (s.29 of the Copyright, Designs and Patents Act 1988).

If you are writing for your own blog or webpage, for a church newsletter, or for no money, then fair dealing probably applies. But what about doing work for free to gain experience, say as a travel writer? Fair dealing may not apply because, even if you are not benefiting commercially, the publisher is.

Unpublished theses and talks

An original thesis will probably be considered an unpublished work 'prepared for the purposes of examination' (see s.32 of the 1988 Copyright, Designs and Patent Act) and, as such, its author will not be in breach of anyone's copyright if she provides sufficient acknowledgement with material quoted.

This section of the Act also exempts unpublished works prepared for the 'purposes of instruction': so if I give a talk, for free, to the Society of Freelance Editors and Proofreaders reflecting the content of this book, can I freely quote from anyone as long as I provide acknowledgements? Perhaps not if someone decided that my purpose was 'commercial' (i.e. marketing for my book). Or what if I talk to the Institute of Art & Law (IAL) on copyright for museum professionals? Again, perhaps not, because the IAL is charging delegates money and paying me a fee to present. And doubly, perhaps not, because I could be seen to be plugging my other book on copyright... but it is arguable.

INFORMATION BANK

[1] Lawyers might disagree with me; the concepts are in some ways rigid, rather than slippery. I mean 'slippery' in the sense that they can be very hard to apply in practice, or to understand when you are sitting with your own set of facts and trying to apply them to the law.

[2] I wrote this chapter with the query 'can I quote this in my book?' in mind, but of course it all applies in other kinds of re-use/copying contexts too: especially copying online (see also Chapter 10, 'Orphan Works'). It is an interesting fact that the publishing and libraries/archives sectors have grappled with these issues in recent years under the guise of 'digitisation'. By this I mean that in order to digitise all of their back catalogues, they had to try to identify copyright owners, and then seek consent for re-use: the online databases that exist today are the direct result of this thrust to digitise (for an example of this see the ARROW project mentioned in Chapter 10, 'Orphan Works').

[3] A Table could also be protected by the law of copyright as a database and, as a database, under separate sui generis database rights. According to a factsheet produced by Queen's University Belfast, Copyright: A guide for the researcher, a single page explaining the offside rule from a book about football has been held to be an infringement of the author's copyright, as have four lines from Kipling's poem If used for an advertisement. Approximately 5 per cent of a work quoted in a book of study notes has also been held to be substantial.

INFORMATION BANK

[4] *Infopaq* is a case before the European Court of Justice on 'temporary copying', which can be a non-infringing act under European law. Infopaq operated a media monitoring business that used an automated data capture method to scan and extract summaries of selected articles from Danish daily newspapers and other periodicals. The Court held that this process was potentially in breach of Article 2 of the Directive and said that the national Court should hear the issues in full. The data capture process was analysed by the European Court to see if it was an exempted act in EU Copyright Directive terms (i.e. temporary copying). It analysed the process as comprising four acts of reproduction: the creation of a TIFF file; a text file; an electronically stored 11-word extract; and a printed sheet containing the 11-word extract. The Court found that the first two were transient/temporary and their creation did not infringe the reproduction ban in the Directive; the third, electronic storage of the extract, could be either transient or not, it was up to the national Court to decide on the facts; and the fourth (print-out) was not temporary copying and was therefore in breach of the copyright law. See *Infopaq International A/S* v *Danske Dagblades Forening*, European Court of Justice 16 July 2009; Directive 2001/29 on the harmonisation of copyright and related rights in the information society: http://europa. eu/legislation_summaries/internal_market/ businesses/intellectual_property/l26053_ en.htm.

[5] If you want to go down the route of looking at other countries' copyright laws, try http:// portal.unesco.org and enter 'collection of national copyright laws' in the search box. For the duration of copyright in the US, go to www. loc.gov/copyright. WIPO Gold portal and look up each national law: www.wipo.int/wipogold/en.

[6] See www.guardian.co.uk/books/2010/ may/01/blake-morrison-lyrics-copyright.

[7] www.mpaonline.org.uk/About/members/ index.html. www.mpaonline.org.uk/Printed_ Music/dist/Music_Sales_Ltd.html?q=music per cent20sales

[8] Music Sales Limited is an international group of music publishing companies, a book and sheet music publisher itself, and also administers rights on behalf of original publishers with whom they have exclusive or non-exclusive deals.

[9] See also Chapter 17, Plagiarism.

8

Arthur Conan Doyle: The curious case of 'revived copyright'

Revived copyright (authors who died between 1925–45)

The industry rule of thumb, helpfully supplied by the Society of Authors, is clear:

> Works written by a European author who died between 1 January 1925 and 1 January 1945 went into 'revived copyright' on 1 January 1996, when the term of copyright was extended from 50 to 70 years.

If you want to quote from a revived copyright work *you can do so without having to clear permission*. You must, however, give the copyright holder notice of your intentions and use may be subject to payment of a reasonable royalty. However, this is still a complex area, as you will see.

Quoting from a work in the public domain (gone out of copyright): and the problem of 'revived copyright'

"Is there any point to which you would wish to draw my attention?"
"To the curious incident of the dog in the night-time."
"The dog did nothing in the night-time".
"That was the curious incident", remarked Sherlock Holmes.

Inspector Gregory and Sherlock Holmes in *The Adventure of Silver Blaze* by Sir Arthur Conan Doyle, first published in 1892. Reproduced with the permission of Jon Lellenberg for the Conan Doyle Estate.

Paperchase

To use the quote in this book my first port of call was to check whether Sir Arthur Conan Doyle (ACD) was indeed out of copyright.

I thought he would be. The author died on 7 July 1930 so, under the old rules (the 1956 Act rather than the 1988 Act) was out of copyright/in the public domain from 1 January 1981 (from the end of 1980): lifetime of ACD plus 50.

But I wanted to double-check so I looked at the Writers, Artists, and Their Copyright Holders (WATCH) database (http://research.hrc.utexas.edu/watch/contact_list.cfm?ArtistID=646) and am glad that I did because this then became a case study on 'revived copyright'.

According to the database, 'Jon L. Lellenberg is the representative of Conan Doyle Estate Ltd, successor to the estate of Sir Arthur Conan Doyle's daughter and heir, Dame Jean Conan Doyle. Copyright in Conan Doyle's published work came back into UK copyright from 1996 to 2000 but has now expired (except for a few writings first published posthumously). In the USA, copyright is claimed for works first published between 1923 and 2002. Unpublished works by Sir Arthur Conan Doyle are in the public domain in the USA but not in the UK. From 2010, UK enquiries will be dealt with by United Agents.'

The revived copyright point worried me. I have always read that revived copyright is possible 'for complex legal reasons' but did not know how this actually worked. So I investigated it.

The 'complex legal reasons' are contained in the Duration of Copyright and Rights in Performances Regulations 1995. The Regulations basically extend copyright protection from lifetime plus 50 years to lifetime plus 70 years, and caused some copyrights to revive in 1996. Under the Regulations, 1995 becomes a transitional year. At 1 July 1995 any works whose copyright expired before that date will have their copyright revive from 1 January 1996 if copyright subsists in another European Economic Area (EEA) country, say the Regulations.

So are we expected to research all the copyright laws in each EEA country to find out the copyright term in each?[1] We could technically do so, but no, actually this is a deeming provision: the 1995 Regulations just want us to create an artificial extension on works falling within qualifying years: it wants us to add on another 20 years of copyright protection as an artificial and arbitrary act, assuming that somewhere in the EEA copyright provision would have been kinder, and lasted longer. (I am grateful to the lawyers for Own-it for confirming that I have not gone mad on this point.) To put it simply, you add on 20 years from 1 January 1996.

'Basically, just assume that it's life plus 70 years because almost all works will have been in copyright in another EU country. If your author died in 1941 then assume that the work is out of copyright from 1 January 2012.' Own-It (http://www.own-it.org)

Here's how it all pans out.

We are looking for a book going into the public domain under the lifetime of the author plus 50 years system, which applied pre-1995.

Working backwards from 1995, we are looking for an author who had died during or before 1945.

Because the Regulations say that in 1945, 1944, or earlier, the date of the author's death, the copyright will have been extended to lifetime plus 70 years in relation to usages of the work from 1 January 1996.

The Regulations further provide that if a work is still in copyright as at 31 December 1995, copyright is extended by 20 years (from lifetime plus 50 years to lifetime plus 70 years). And that any arrangements made before 1 January 1995 will stand (s.23) if the work is out of copyright as at 1 January 1995.

Moral rights also revive under the Regulations.

And finally, the Regulations say that there will be a deemed licence on the payment of a royalty to the copyright owner, but you must notify the owner of your use (reg. 24).

Back to Arthur Conan Doyle	Arthur Conan Doyle died on 7 July 1930, so, as we have seen, under the old rules (the 1956 Act not the 1988 Act) his published work was out of copyright/in the public domain from 1 January 1981 (lifetime of Arthur Conan Doyle plus 50 years).

However, during 1995/6 his UK copyright was revived, so from 1 January 1996 he was in copyright again until 1930 plus 70 – the end of 2000 (his works came into the public domain from 1 January 2001). |
| **But what if our author died in the 1940s? e.g. 7 July 1940.** | Under the old rules his works would have fallen into the public domain in 1990 (from 1 January 1991); but copyright would have revived on 1 January 1996 so 1940 plus 70 means out of copyright at the end of 2010, so 1 January 2011.

Since ACD died in 1930, his UK copyright, even though it temporarily revived, has now lapsed again, so his works are in the public domain and I can quote him without requiring permission or making any payment! |

UK rights

Robert Kirby, for United Agents, was very quick and helpful in confirming that the works of Sir Arthur Conan Doyle are 'out of copyright in Europe'. But, he said, 'The Casebook of Sherlock Holmes is in copyright in the USA, its territories and dependencies. These stories fell into the 20-year extension period of the 1998 Bono Copyright Extension Act [which did similar things as the 1995 Regulations did in the UK]. Because the characters[2] (at least those in the Casebook) are still in copyright in the USA.'

US rights

For this book to be distributed in the US I needed to check for US copyright. The Conan Doyle Estate's US representative, Jon Lellenberg, was also quick to come back to me and able to confirm the following (in addition to verifying that the quote as quoted above is correct):

> 'In the US, the old copyright system of 26 years renewable for another 26 was replaced on 1 January 1978, by the US Copyright Act of 1976. Its principal purpose was to make US practice consistent with most international practice at the time, i.e. an author's life plus 50 years, but because many authors had sold their rights in their works according to the previous shorter term of protection, it extended all subsisting copyrights at the time the law was passed for a period of 75 years from the date of original publication (and expiration of copyright had been suspended as of 1964 while Congress debated a new law). It also empowered the spouses, children or grandchildren of deceased authors to recapture the latter's copyrights by going through certain procedures. Dame Jean was one of the first people eligible to do so. Her 'recapturing' in relation to her father's Sherlock Holmes tales applied to the novel The Valley of Fear and the short story collections His Last Bow and The Case-Book of Sherlock Holmes. The first two eventually passed into the public domain, and the Case-Book would have at the end of 2003, except for the 1998 Copyright Extension Act which added 20 additional years of protection to all subsisting copyrights. Character rights in the United States flow from a combination of copyright, trademark, and unfair competition laws.'

INFORMATION BANK

[1] If I did want to lose several thousand woman hours of time, and to work out which countries were in the EEA, and what copyright laws applied in each one, and then read each law and work out the current position, I could start by visiting the resources mentioned in Chapter 7, Quoting/Extracts (1. *Which country's laws apply?*). But I doubt that even an enthusiast like myself would be able to justify the time.

[2] Take care: characters are not necessarily covered by copyright under the UK Act: see Chapter 16, Other Very Interesting Bits and Bobs.

Duration of Copyright and Rights in Performances Regulations 1995 (1995 No. 3297) http://www.opsi.gov.uk/si/si1995/Uksi_19953297_en_1.htm

9

'Criticism or Review' and 'Incidental Inclusion'

Exceptions:
fair dealing/
incidental
inclusion/
documentary/
tabloid
journalism

............................

*Technically it is an 'exception' but I'll use the word 'defence' here.

Fair dealing as a defence* will rarely apply. You have to assume that re-use of another's copyright material will NOT be allowed (without permission). However, in very limited, restrictive situations you can use another's copyright material relying on the defence of fair dealing. But to do so is to take a risk, and you need to decide if that risk is worth taking (see Chapter 18, Going to Law; see also Chapter 10, 'Orphan Works'). And it will never be fair dealing if you fail to acknowledge the originator's contribution to the work you are copying/re-using (unless we are talking about current events reporting in a sound recording, film or broadcast; s.30(3)).

Case 1, fair dealing: criticism or review and current event news reporting

Pro Sieben Media AG v Carlton UK Television Ltd & Twenty-Twenty Television Ltd (1999) WLR 605

In this case the Court of Appeal reversed a lower court decision. It held that Carlton TV was allowed to rely on the defence of 'fair dealing' – both fair dealing for the specific purpose of 'criticism'; and fair dealing for the specific purpose of 'current event news reporting'. Carlton TV and Twenty-Twenty made a television documentary and re-used a clip of an 'exclusive' interview between the partner of 'Mandy-pregnant-with-octuplets-Allwood' and presenter Dermot Murnaghan, which had originally been commissioned and aired by the German television channel, Pro Sieben (Channel 7). Pro Sieben had paid £30,000 for the exclusive right to broadcast the original interview, itself an 'exclusive' negotiated by public relations man Max Clifford acting on behalf of Mandy Allwood in a UK deal with the *News of the World*.

The extract/clip: Carlton had included a 30-second clip of the original footage; that footage did not include any words spoken by Mandy Allwood, only the sound of her partner counting as he was shopping for eight teddy bears and voiced-over in German; the Carlton audio was additionally partly obscured by Dermot Murnaghan's voiceover.

To give a flavour of the Carlton programme, this was Dermot Murnaghan's introduction:

> 'Tonight, how to make big money selling your private life to the press, your relatives' private lives, the private lives of your friends or former partners. Our secret cameras go on the trail of the people cashing in on the life of Mandy Allwood. Like her former husband, who for £10,000 is ready to dish the dirt.'

The Court of Appeal decided that use of the clip sat within the restrictive boundaries of fair dealing for news reporting, it being a current affair of general public interest that Mandy Allwood was having octuplets and was selling her story (and 'the volume and intensity of media interest was sufficient to bring the media coverage itself within the ambit of current events'). It was also fair dealing for criticism – meaning criticism of the press and public relations practice of chequebook journalism and its distortive, skewing effects on what in the world today is reported as news, and what drops off the news agenda ('chequebook journalism is deeply inimical to truth'), as illustrated by the case of Mandy Allwood, and also by the following other stories mentioned in the Carlton programme: a man who had been struck by a racehorse at Ascot when drunk and wandering onto the track; the mother of a baby abducted from St Thomas's Hospital and returned after 17 days; the parents of sextuplets; a woman rescued off the Cairngorms surviving severe weather conditions; a holidaymaker attacked by a shark in the Red Sea and saved, injured, by dolphins – all of whom (except the dolphins!) had earned money from selling their stories.

In relation to the Mandy Allwood story itself, the Carlton programme was criticism or review of the fact that Pro Sieben was prepared to pay large sums of money for an exclusive interview, whereas Carlton was not so prepared.

Note: the main case was about the inclusion of the 30-second clip. There was a separate copyright infringement action relating

to the straight copying of the whole Pro Sieben programme which had been carried out in order for the clip to be extracted.

The acknowledgment: Pro Sieben's logo appeared with the clip and the Court of Appeal held that that was sufficient acknowledgement for the purpose of s.30 and s.178 of the 1988 Act (although acknowledgement was not strictly needed as this was a broadcast see s.30(2)).

Interesting sub-points were made in this case. Fair dealing for the purpose of criticism: 'If the fair dealing is for the purpose of criticism that criticism may be strongly expressed and unbalanced without forfeiting the fair dealing defence; an author's remedy for malicious and unjustified criticism lies, if it lies anywhere, in the law of **defamation** not copyright' (see Chapter 12, Libel and Privacy). It does not matter if the audience understands the criticism as criticism ... that is a red herring, 'the mental element on the part of the user is of little importance'. Also: 'criticism of a work need not be limited to criticism of style. It may also extend to the ideas to be found in a work and its social or moral implications...'

This is a good place to repeat – and it does bear repeating – that copyright protects your intellectual property rights, but you need to look at other parts of the law for assistance with other legal problems you may more frequently come across. This includes privacy law in the use of pictures; or libel law when criticising someone or discussing issues affecting people in your writing. Or perhaps data protection if it is a photograph of a child; or freedom of information if it is protected information; or breach of trust or breach of confidentiality. And sometimes you can sue – or be sued – under all counts at the same time, if, for example, a feature published with a photograph caused upset on copyright, libel, data protection, breach of confidence etc. and privacy grounds.

Evidence by series editor Ms Dorothy Byrne seems to have provoked the trial judge into forming a dim view of Carlton TV's defence, which was then overturned on appeal. The Court of Appeal however found Carlton's programme to be 'skilfully made' and appeared empathetic to the message about the negative effects of chequebook journalism.

Case 2, criticism or review accepted by the Court of Appeal

A Clockwork Orange case

Clips from the classic arthouse film *A Clockwork Orange* were used in a Channel 4 documentary film, *Forbidden Fruit*, part of the *Without Walls* arts documentary series. The use was accepted by the Court of Appeal to be arguably fair dealing for the purposes of criticism or review, despite the fact that the clips amounted to over 8 per cent of the original Stanley Kubrick film, and about 40 per cent of the documentary.

The film, directed by Stanley Kubrick and based on Anthony Burgess' 1962 novel, was first screened in the UK in 1972–3 but was withdrawn from the UK in 1974 by the copyright owner, Warner Films, at the request of the director.[1] It continued to be screened abroad, e.g. in France, and in 1993 Warner took legal action against the Scala cinema which screened the film in London contrary to the ban.

In 1993 Channel 4 commissioned Fabula Films to make a documentary about the award-winning film and invited Kubrick to take part. Kubrick refused. Just before the documentary was due to be aired, Time Warner sought an injunction to prevent the broadcast on the basis of breach of copyright. That the Channel 4 documentary used a 'substantial part' of the original film in its documentary was not an issue. The legal issue turned on Channel 4's claim that its use of clips of the film was justifiable under the 1988 Copyright Act's fair dealing defence of criticism or review (s.30).

The Court of Appeal supported Channel 4's arguments and the injunction was lifted ('discharged'). In the end, the programme was broadcast on 26 October 1993 at 9.31pm.[2]

Warner Bros had argued that the programme was not so much a genuine 'criticism or review' of the film, as a challenge to its decision to withdraw the film from UK audiences: a sensationalist approach and part of a campaign to persuade Time Warner to allow the film to be shown again in the UK. The trial judge said this was arguable, but the Court of Appeal pointed out that even given that possible argument, the defence of fair dealing for 'criticism or review' could still be available to Channel 4:

- 'The defence is not lost if the offending excerpts might arguably be thought to be (in relation to the original film) unbalanced

or unrepresentative' (there was an accusation that Channel 4 used only 'violent' clips).

- The defence can still apply where the criticism is of the 21-year ban, rather than the film itself.
- The defence is arguable even if a large percentage of the documentary is made up of clips from the film (the clips made up 12 minutes (40 per cent) of the 30-minute documentary; 8 per cent of the film.
- And *obiter*: the defence can still be used if the criticism attaches to surrounding elements:

'the criticism need not be primarily directed at [the] work infringed, but may be directed at another work ... *Hubbard* v *Vosper* ... makes clear that the criticism relied on need not be directed at the work, but may be directed at the thought and philosophy behind the work (ibid. at 94f.).'

Lord Justice Neill, Westlaw transcript, Court of Appeal in *Time Warner Entertainments Co LP* v *Channel Four Television Corp Plc* 5–6, 22 October 1993. Applying *Hubbard* v *Vosper* [1972] 2 QB 84.

Case 3, tabloid reportage: fair dealing on the grounds of criticism or review and/or incidental inclusion?

Piers Morgan's television commentary on the Beckhams

This case involved a BBC programme presented by Piers Morgan about Victoria Beckham and tabloid journalism. It posed the basic question: does the media control Victoria Beckham or does she control the media? In the course of the television broadcast, stills of private photographs of Mrs Beckham, taken by freelancer Jason Fraser, were seen for two or three seconds at a time, several times over. Sometimes the photographs were shown in themselves, sometimes as part of the layout of a magazine or newspaper article, where the headline may have been more the 'point' of the discussion than the photograph *per se*. The case is useful in its discussions of the legal defences to copyright infringement on the grounds of incidental inclusion; and fair dealing for criticism or review. It also makes *obiter* remarks on the special status of photographs in particular. The High Court (Chancery Division) decided in the end that most of the photographs had been used in the television programme justifiably: their use being capable of being defended by reason of fair dealing for the purposes of criticism or review (in spite of the fact that the photographer had

refused the channel permission to use them); only two were not defensible in that way.

The Court held that it was acceptable to criticise and review the culture of tabloid press reportage or, in words used in the case transcript, 'Fleet Street's rather warped news agenda' and celebrity lifestyle; to infringe copyright there was no need for the criticism or review to focus very narrowly on the photographs themselves (albeit that the television programme had analysed the photographs themselves as well in being able to offer the suggestion that some of them had been 'staged'; i.e. that Mrs Beckham had had prior knowledge that the paparazzi were going to be photographing her).

Note that the case is about copyright law, and not about any separate legal issues of privacy etc., which could have been argued.

Interestingly, and unlike in the Paddy Ashdown case discussed in Chapter 13, Mr Justice Mann commented at paragraph 64 of his ruling as follows:

'Risk to the commercial value of the copyright may go towards demonstrating or creating unfairness, but it does not follow that any damage or any risk makes any use of the material unfair. If it did then there could be no use of copyright material in criticism or review if it could be said that that use might damage the value of the material to the copyright owner. That would be inconsistent with the purpose of the section which is to balance the interests of the copyright owner and the critic. It is all a question of balance. In the present case I consider it to be clear that the level of risk of damage (whatever it may be) is not sufficiently great to mean that the use of the photographs was unfair. The exploitation of the photographs in the programme was not gratuitous or lingering, so if there was any risk of over-exposure it was kept to an acceptable minimum. So far as this factor is concerned the use of the photographs was well on the "fair" side of the fair/unfair borderline (wherever that may lie).'

Note on photographs and defence of fair dealing for criticism or review

'In assessing whether the dealing is fair the court can have regard to the actual purpose of the work, and will be live to any pretence in the purported purpose of the work:

'... it is necessary to have regard to the true purpose of the work. Is it a genuine piece of criticism or review, or is it something else, such as an attempt to dress up the infringement of another's

copyright in the guise of criticism, and so profit unfairly from another's work?' Time Warner, supra, at p.14

- In the same vein, the amount of the work used can be relevant:

'I may add, however, that the substantiality of the part reproduced is, in my view, an element which the Court will take into consideration in arriving at a conclusion whether what has been done is a fair dealing or not. To take an example, if a defendant published long and important extracts from a claimant's work and added to those extracts some brief criticisms upon them, I think that the Court would be very ready to arrive at the conclusion that that was not fair dealing within the section.'

Mr Justice Morton in *Johnstone* v *Bernard Jones Publications Ltd* [1938] 2 Ch 599 at 603–4.

- 'However, this must be carefully applied in relation to photographs. It makes more sense in relation to extended literary or musical works. If one is critiquing a photograph, or using it for the purpose of criticising another work, then the nature of the medium means that any reference is likely to be by means of an inclusion of most of the work because otherwise the reference will not make much sense. This degree of care is particularly appropriate in the context of a television programme where the exposure is not as (for example) continuous or permanent as publication in printed form would be.' Mr Justice Mann paragraph 55

Note: photographs are excluded from the defence of fair dealing for current events news reporting by s.30(2): see Chapter 13, Journalists and Newspaper Editors. Photographs are also protected by moral rights: the right to privacy in photographs commissioned for private and domestic purposes (s.58).

The defence of Incidental Inclusion

During the course of the Beckham case, the Court also had to consider the defence of incidental inclusion and in doing so looked at the *Panini* case.

Guidance on incidental inclusion can be found in *Football Association Premier League Ltd* v *Panini UK Ltd* [2004] FSR 1. In that case, the defendants had published photographs of Premier League footballers in their club strip, which included Premier League or club logos; the League and clubs claimed copyright in their logos. The defendants relied on the defence of incidental

inclusion, and it was rejected on the facts of the case. Lord Justice Chadwick said that the question of whether there was incidental inclusion:

'is to be answered by considering the circumstances in which the relevant artistic work – the image of the player as it appears on the sticker or in the album – was created'.

And whether or not the inclusion is incidental:

'turns on the question: why – having regard to the circumstances in which the [allegedly infringing work] was created – has [the original copyright work] been included in [the former].' (at p.12)

He went on to hold that commercial, as well as aesthetic, considerations came into play in that consideration. Lord Justice Mummery (at p.15) observed that:

' "incidental" is an ordinary descriptive English word ... The range of circumstances in which the word "incidental" is commonly used to describe a state of affairs is sufficiently clear to enable the Courts to apply it to the ascertainable objective context of the particular infringing act in question.'

One Beckham photograph was considered by the Court of Appeal to have been incidentally included ('Beckham 14') and one was not ('Beckham 12').

| Not incidental (so infringing/ not defensible): Beckham 12 | 'The inclusion of Beckham 12 juxtaposed to the headline about the kidnap plot had been deliberate. The programme was about the newspaper treatment of celebrity stories and the juxtaposition of the photograph with the headline was part of that treatment. When that treatment was considered by the programme it was that combination that made the display of the photograph something that occurred for the purpose of criticism or review. But that same factor meant that the photograph could not have been incidentally included. The broad picture of the page including the photograph followed by the zooming in was not merely a production technique to show the page in a more interesting way but was a deliberate way of placing the page in the context of the |

overall story. In that context the inclusion of Beckham 12 had not been incidental.'

'...This conclusion was reinforced by the fact that the lower part of Beckham 12 had been deliberately obscured or shadowed in order to focus attention. It was significant that the shading had not been applied to the whole of the photograph. If the real point had been the headline, then one would have expected the whole photograph to have been shaded. The leaving of the upper part of the photograph unshaded and within the frame suggested that the photograph was significant in the eyes of the programme makers and this in turn suggested that its inclusion was not incidental.'

From the Beckham's case, *Fraser-Woodward Ltd* v *British Broadcasting Corp*; High Court of Justice (Chancery Division), 23 March 2005, [2005] EWHC Ch 472.

Incidental (so not infringing/defensible): Beckham 14

'Beckham 14' had been taken by an Italian photographer who had assigned his copyright. 'It was a photograph of Victoria Beckham on her own. ... It appeared as an integral part of the headlines or coverage of the Beckham kidnap plot. A small photograph appearing within a newspaper headline. The focus of the filmed shot was on the headline. In the run up to the shot, the story had been introduced by Mr Morgan, there were three separate shots of headlines appearing in the *News of the World*, followed by a brief clip from a BBC News broadcast of the item and then the relevant headline and Beckham 14 appeared.

'The point of Beckham 14 had been to show the headline about the kidnap plot. While it appeared in the context of criticism or review of other works, it did not appear "for the purpose" of criticism or review.

... the focus of the filmed shot was on the headline. The headline had been included as an example of another sensational headline and in that context Beckham 14 was there because it happened to be there in the original headline. Whilst it might have been there to lend interest to the original headline, its appearance in the programme shot was incidental. ...

'...The theme of the programme ... moves onto an occasion featured in the newspapers when it was reported that there was a

plot to kidnap Mrs Beckham and her family. To the accompaniment of words taken from a TV news item, the programme then showed Beckham 14. This is quite hard to spot. What is actually shown on screen, for just over 4 seconds, is a headline appearing at the bottom right hand part of [the front page] of a newspaper. In very bold type is the headline: "£5m PLOT TO KIDNAP POSH AND KIDS" ... To the right of the headline is a small square of text – the beginning of the account of the story. Tucked in the gap bounded by the words "PLOT TO", "KIDNAP" and "KIDS" on three sides, and the text on the fourth, is a small photograph of Mrs Beckham. ... a little bigger than a passport photograph. The full picture (which was not shown on the programme, because the programme merely reproduced newspaper photographs) was a three-quarter length shot of Mrs Beckham taken out of doors somewhere, which looks as though it might have been a little more posed than the other photographs, but nothing turns on that. Although the shot is just a shot of her head, and the rest of the photograph has been cropped, no point was taken by the defendants that they had not reproduced a substantial part of the original.

'... This is the small photograph appearing within a newspaper headline. The focus of the filmed shot in the programme is on the headline. It zooms in slightly during the four seconds it is shown, but that is obviously to create a little drama or visual interest. In the run up to this shot the story was introduced by Mr Morgan, and there were three separate shots of headlines appearing in the News of the World, followed by a brief clip from a BBC News broadcast of the item. Then the relevant headline and Beckham 14 appear. I am satisfied that the headline appears as an example of another sensational headline; that is why it is there. In that context the small photograph of Mrs Beckham is incidental – it is there because it happened to be there in the original. While it might have been there to lend interest to the original headline, its appearance in the programme shot was, in everyday terms, incidental ...'.

Fraser-Woodward Ltd v British Broadcasting Corp; High Court of Justice (Chancery Division) 23 March 2005.

Case 4, fair dealing for the purposes of criticism or review rejected by Chancery Court in TV listings case

BBC v BSB [1992] Ch 141

In this case, the High Court (Chancery Division) found that British Satellite Broadcasting (BSB) was justified in using short edited highlights of 1990 World Cup matches on the grounds that the use of the footage (clips ranging from 14 to 37 seconds) was fair dealing on the grounds of current news reporting. It did not matter that the programme being 'copied' was a sports-specific programme: it was still current events and newsworthy and the clips were fairly acknowledged. (Although acknowledgement was not strictly needed as this is a broadcast see s.30(2) of the 1988 Act). The clips used were of goals or specific highlights and did not undermine the value of the original broadcasts: viewers seeing the highlights on BSB would not have dispensed with viewing the matches on the BBC.

There is also a subtle point here about quality and quantity: in *Designers Guild* (Chapter 4), I emphasised the Court's insistence on looking at the quality of the part that had been substantially copied; not the quantity. That was in relation to deciding whether there had been unlawful copying.

Here, in relation to whether or not the defence of fair dealing is available, the court emphasised that it can be a question of both quantity and also of quality.

s. 178 of the 1988 Act. Minor definitions

.........................

See s.30 of the Copyright, Designs and Patents Act 1988 as reproduced in Chapter 13, Journalists and Newspaper Editors.

... 'sufficient acknowledgement' means an acknowledgement identifying the work in question by its title or other description, and identifying the author unless:

(a) in the case of a published work, it is published anonymously;

(b) in the case of an unpublished work, it is not possible for a person to ascertain the identity of the author by reasonable inquiry'.

A note on the defence of innocent infringement: e.g. the point of putting '© Gillian Davies 2011' at the bottom of my website is to put people on notice that the content rights belong to me, but also: if someone claimed to have thought it was all up there for free use and copying, I could say: 'no, you knew about it and therefore you cannot rely on the defence of "innocent infringement".'

It is also relevant to damages:

Section 97 of the 1988 Act. **Provisions as to damages in infringement action**

(1) 'Where in an action for infringement of copyright it is shown that at the time of the infringement the defendant did not know, and had no reason to believe, that copyright subsisted in the work to which the action relates, the claimant is not entitled to damages against him, but without prejudice to any other remedy.

(2) The Court may, in an action for infringement of copyright, having regard to all the circumstances, and in particular to

 (a) the flagrancy of the infringement, and

 (b) any benefit accruing to the defendant by reason of the infringement, award such additional damages as the justice of the case may require.'

Remember the copyright defences are very strictly applied: i.e. they will not often work. You have to assume that something is protected by copyright and that you cannot use it without permission, except in very limited circumstances.

[1] Uncomfortable about accusations by members of the public, police and the Judiciary that the film's tramp-beating scene had provoked a number of 'copycat killings'. *A Clockwork Orange*'s tramp-kicking scene is, indeed, not for the faint-hearted.

[2] The time is very important and central to the case: 9:30pm is clearly before the 10pm 'watershed' (the Independent Television Commission Code at the time barred the broadcast of '18'-rated material before 10pm).

10

'Orphan Works': Gigantic wall of apathy?

What happens if you want to use material from a magazine or newspaper that no longer exists, or you can't find the copyright owner, or the owner does not respond to you? Here we are entering the bewildering arena of orphan works. Orphan works are works (writing, photographs, etc.) whose rightsholder cannot be identified or found. (This chapter should be read alongside its companion on Extracts and Quotes, Chapter 7).

The short answer is: first, do not publish or otherwise copy a copyright work unless you have permission; and secondly, always assume it is in copyright. To do otherwise is to run the risk of litigation and/or paying hefty retrospective fees.

The not-so-short but alternative and perhaps more practical solution is:

1 Try to locate the copyright author
2 Keep track of your efforts, and keep records
3 If you do have to go ahead and publish without permission, use a disclaimer
4 Be prepared to pay retrospectively if required: and budget for that
5 If you do get permission, make sure it is in writing. With a verbal consent you know the risk of litigation is minimal, but it does not stop another person in the same company, or another copyright owner, from popping up separately, or in the future, and claiming to know nothing about the verbal consent.

1. Locating copyright holders

The first port of call (after the imprint page) must always be the publisher. Find out who published the orignal, where and when. The Rights Department at the publisher should be able to tell you who to contact for permission, and they may even be able to get permission for you themselves. But then again, they might not: we

live in an imperfect world where publishers are under-resourced, often experiencing a high turnover of staff. Records may be poor. No one may know.

A typical comment comes from Helen Bleck, former managing editor at Canongate Books in Edinburgh, and now a freelance editor. She frequently had to help authors clear copyright for works quoted in their books (often lyrics, but also poetry and quotes from novels and factual works). Helen says,

> 'it was an absolute nightmare – the quote was often not completely accurate, making it harder to source the origin, or was taken from somewhere else that had also been citing it, but wasn't the original source. We often had to track through several publishers or licence holders before we could trace the true copyright holder, and often they weren't available for months (Pink Floyd were particularly difficult to hunt down!).

> Frequently, copyright holders were very happy to be quoted, and often let us use a short quote for no charge; but sometimes our authors ended up having to cut the quote and rewrite the text, because the copyright holder was either charging an impossibly high amount or did not want their words to appear in the work – for a variety of reasons. It was essential to find out if this was the case long before the book went to print! Publishers were easier to deal with than individual copyright holders, as they usually had a set way of handling requests and were trusted by the copyright holders themselves. But training in hunting down copyright permissions was very much "on the job" and a case of learning by experience and trying to build up a list of helpful contacts; an author who took the trouble to sort out their own permissions

The following quote is out of copyright and in the public domain:

'One should either be a work of art, or wear a work of art' Oscar Wilde 1854–1900, first published as part of 'Phrases and Philosophies for the Use of the Young' which appeared in the short-lived magazine, *The Chameleon* in December 1894.

Note that unpublished works by Wilde remain in copyright in the UK until 2040.

Information from WATCH: http://tyler.hrc.utexas.edu//index.cfm and Merlin Holland for the Estate of Oscar Wilde.

was blessed by the editorial department! A note for authors: often people will be much kinder and more generous to an individual author than to a publisher (who they assume has more money and will be paying).'

If the author is deceased contact the publisher first, then the next of kin if you can find them.

As well as using a search engine such as Google, and checking the Amazon website, try these resources:

The best resources

WATCH (Writers, Artists, and Their Copyright Holders)

Database containing contact details for copyright holders whose works are held in UK or US libraries and archives. (See also Chapter 7, Quoting/Extracts) www.watch-file.com (redirects to http://tyler. hrc.utexas.edu).

Companies House

The Companies House WebCheck searchable database will help to trace a publisher, and is especially useful where publishers have changed their name (it does happen – see below) or have been acquired by another company.

For example, I want to publish the following quote:

'An incompetent lawyer can delay a trial for years or months. A competent attorney can delay one even longer' Attorney General Evelle J Younger, 1971.

The quote is cited at p.18 in a book by Peter Seddon *The Law's Strangest Cases*, published by Robson Books, an imprint of Anova.

Let's ignore the fact that this is a pretty ubiquitous lawyer-joke quote and all over the internet (and therefore arguably in the public domain so no copyright clearance is necessary). And that it first appeared in the *LA Times*. Let's just say that it is a quote first used in the book by Seddon, and that I want to ask permission to repeat it.

Using the Companies House free search engine I can get to the publisher: Anova is 'Anova Books Group Limited', formerly known as 'B.T. Batsford Chess & Bridge Limited' (2007) and before that 'Anova Books Company Limited' (2006), and 'Ludgate 362

Limited (2005)). Defunct companies are also listed but marked as 'insolvent', 'dissolved' or 'in liquidation'. www.companieshouse. gov.uk. (See also FOB in *Other resources* below).

Publishers' Association

The leading trade organisation for book, journal, audio and electronic publishers in the UK. If you know the name of the publisher and need further details, try searching the PA's member database at www.publishersassociation.org.uk. From Join Us scroll down to the Member List. The publisher of this book, for example, A&CBlack, is listed with contact details. However, neither 'Robson' nor 'Anova Books' are listed.

Bowkers Books in Print

www.booksinprint.com. This is a subscription-only service mainly used by libraries and publishers and not individuals, but you might be able to prevail on your local library to try it for you. It identifies all known editions of books in all world markets and will tell you whether a book has gone out of print or not; most importantly for tracing copyright owners it identifies all publishers past and present and what markets in the world a book is, or has been, available. Bowkers allowed me to test the service so I searched for five titles:

1 Kenneth Clark's *The Gothic Revival* first published in 1928: Bowkers' Books in Print told me that the book is still in print in the US and South Africa but is out of print elsewhere. In the US it is available to order ('Active', aka 'In Print') from two different publishers.
2 *Stories for Seven-Year-Olds* by Sara and Stephen Corrin: all editions around the world appear to be out of print.
3 *Learning the Law* by Glanville Williams was published by Stevens running to 11 editions 1945–93 (and the 7th edition four impressions, 11th edition, eight impressions) but also published by Sweet & Maxwell 2006, Universal Law Publishing Company, Witherby & Company and Bow Historical Books.
4 *The Rhetoric of Fiction* by Wayne C Booth: many editions have gone out of print but some are still available. A 1983 edition published by the University of Chicago Press came up as out of print on one ISBN but is still available on another ISBN.
5 *Fly Fishing* by J.R. Hartley Random House 1991: out of print in Canada, Australia, UK; still in print in South Africa.

Note that publishers might provide a book 'on demand' these days regardless of whether a book is technically in- or out-of-print.

Society of Authors

If you are looking for an author, or an author's agent, rather than a publisher, the Society of Authors is a good first port of call. It acts as literary representative for the estates of:

- Walter de la Mare
- T. S. Eliot (stage, screen and audio rights – plays)
- E. M. Forster
- A. E. Housman
- Philip Larkin
- Compton Mackenzie
- George Bernard Shaw
- Lytton Strachey
- Virginia Woolf and
- W. B. Yeats.

As well as other authors listed on its website http://www.society ofauthors.net/literary-estates-and-permissions

In addition, it has a searchable database called Find an Author: http://www.societyofauthors.org/WritersAZ (by name, subject or work area, e.g. 'ghostwriter'; you will even find me there for example: listed under both my names).

2. Keep track of your efforts, and keep records

The point about keeping records is evidential of course: you want to be able to say: 'look, I was trying to do the right thing and here are the people I thought it sensible to approach'.

The specific legal point behind this is drawn out by Ian Bloom, media partner with law firm, Ross & Craig Solicitors (and contributor to this book), who commented that:

'It is best to avoid publishing or publish with the disclaimer – and to be in a position to show what steps were taken to find the copyright holder. That way, if challenged later, the writer/ publisher can evidence good faith and is most unlikely to have to pay damages based on deliberate breach. If damages were awarded, they would be 'normal' royalty rates about which expert evidence could be given'.

You might escape damages altogether if you can show you have made sufficient effort to contact a copyright owner; or at worst you will only have to pay a minimal sum. The relevant section in the legislation is, as ever, in the 1988 Copyright, Designs and Patents Act:

Section 97 Provisions as to damages in infringement action

1 Where, in an action for infringement of copyright, it is shown that at the time of the infringement the defendant did not know, and had no reason to believe, that copyright subsisted in the work to which the action relates, the claimant is not entitled to damages against him, but without prejudice to any other remedy.

2 The court may, in an action for infringement of copyright, having regard to all the circumstances, and in particular to:
 (a) the flagrancy of the infringement, and
 (b) any benefit accruing to the defendant by reason of the infringement, award such additional damages as the justice of the case may require.

Records and evidence would include emails and letters sent, and adverts taken out seeking a copyright owner (e.g. an advert in the *TLS*, *The Bookseller*, Society of Authors or SfEP newsletters would be looked upon favourably as a commendable effort in trying to find the rights owner).

Be wary of filling in online query forms, such as the Contact Us form used on the website of the MCPS (Mechanical Copyright Protection Society). If they do not respond, and they did not to me, you will not have a record of your having done this unless you make a separate copy for yourself: I usually email myself a copy of what I've sent).

3. Use a disclaimer

If you decide to publish anyway, and use a disclaimer, a form of words such as the following may be appropriate:

'Every attempt has been made to identify the copyright owner for this work and to obtain permission to publish it. If you wish to contact us regarding this matter please do so by contacting <xxx>....'.

4. Be prepared to pay retrospectively

Finally, all you can do is be prepared to pay up retrospectively, if required, and budget for it.

The future: New laws and orphan tools in pipeline?

An EU Directive was published on 25 May 2011. It proposes an EU-wide system of recognition of 'orphans' to facilitate their use after prior diligent search (http://ec.europa.eu/internal_market/copyright/docs/orphan-works/proposal_en.pdf). Under the EU proposal authors could end 'orphan' status if they discover a mistake. But questions remain about the practicalities of operating such a system.

On a more practical level, ARROW (Accessible Registries of Rights Information and Orphan Works) is an on-going project funded by the Commission. Project partners include a broad range of national libraries, publishers and collective management organisations. In particular, it aims to develop ways of clarifying the rights status of orphan and out-of-print works (motivated by the desire to clear content for digitisation and digital library initiatives). Solutions envisaged by the venture include the establishment of systems for the exchange of information about the rights status of works, the creation of a registry of orphan works and a network of rights clearance centres. But at the time of writing these initiatives have not been implemented (www.arrow-net.eu).

In the UK a law intended to help us deal with orphans was drafted in the Digital Economy Bill 2009, but was then dropped by the time that Act became law in the Digital Economy Act 2010. But the idea may yet be resurrected.

Other content management initiatives, including Attributor and iCopyright's service, could reduce the problem of orphans in future, although the difficulty will always be widespread. Is there any point in being able to tag tiny amounts of content when the vast majority of digital content, especially, is untagged and untraceable? There is also the question of security: what can be locked up (or fingerprinted) can be unlocked (or stripped of fingerprints).

'Not commerically available'

As I have discussed above, orphan works remain a problem, and legislation is required to allow authors and publishers to write and publish with greater certainty. The 2009-10 UK Digital Economy Bill tackled orphans and other less headline-grabbing clauses. But this, and many other clauses, were axed during the parliamentary wash-up before the General Election in May 2010. The Act, as it passed into law, contained only provisions to do with ISP's liability for monitoring illicit online behaviour.

That said, according to senior figures in the UK publishing world[1], the new problem is not orphans but 'out-of-commerce': this covers situations where, yes, we can identify a copyright owner, but the work is no longer commercially available – in other words, a book has gone out of print. Worse still is the problem that for ebooks we do not actually know whether it is commercially available because there is no Bowker's Books in Print equivalent for ebooks. At present, no one knows exactly what is being published.

Resources

Google

In the US, the Google-Authors' Guild draft (rejected) settlement tackles orphan works (see Chapter 15, Dates, Deadlines and Money).

Other resources

Artists

The Association of Illustrators (www.aoiportfolios.com); and artists who are members of and represented for copyright purposes by DACS (www.dacs.org.uk).

Authors

Association of Authors' Agents: leads to a Members' Directory of Agents www.agentsassoc.co.uk/index.php.

The Book Trust: Book Trust, Book House, 45 East Hill, London, SW18 2QZ. www.booktrust.org.uk

British Music Information Centre: searchable database of classical composers and publishers. www.bmic.co.uk

FOB: Firms out of business supplements WATCH http://www.fob-file.com.

Contact an Author: www.contactanauthor.co.uk: authors must register to be included (at a cost of £45 per year). There is no fee for searches and these can be done by name as well as by category e.g. law writer, chidren's book illustrator etc., or under location e.g. Edinburgh.

Scottish Book Trust apparently holds information on writers living in Scotland, but I contacted them and was asked if I was sure I didn't want to ask Publishing Scotland, which I did not, and which did not augur too well... Publishing Scotland does publish a yearbook of members including publishers, individual authors and editors (www.publishingscotland.org).

US: Author's Registry: http://authorsregistry.org.

Welsh Book Council: www.cllc.org.uk.

Journalists, periodicals and journals

Some writers will be listed on the freelance databases of the NUJ or DWP's www.journalistdirectory.com/journalist/.

Ulrichsweb: for periodicals and journals: a subscription-only service which, again, a librarian may help you with.

Music

Mechanical-Copyright Protection Society and Performaing Rights Society (MCPS/PRS): the MCPS collects and distributes royalties generated from the recording of music and distributes the money to its members (music writers and publishers). (I twice sent a query to MCPS about mechanical copright and got no reply). See the PRS: http://www.prsformusic.com/Pages/default.aspx.

Music Publishers Association: to help identify music publishers: see Lyrics example in Chapter 7, Quoting/Extracts. www.mpaonline. org.uk.

Phonographic Performance Limited or PPL (www.ppluk.com). PPL licenses the use of recorded music in the UK on behalf of 45,000 performers and 5,750 record companies.

NIBWEB: some writers and editors who work on information books for children are here: www.nibweb.co.uk. Has a Find an Author Search facility.

Poetry

For some poets see www.applesandsnakes.org.

Plus

Expertsources.com: to search, obviously, by subject.

Real-life Private Eyes do exist and there are online resources including www.traceline.co.uk/trace-line.

Further information

Note that the Copyright, Designs and Patents Act 1988 makes specific provision to allow the use of copyright material for certain films:

> **66A**. *Films: acts permitted on assumptions as to expiry of copyright, etc.*

(1) Copyright in a film is not infringed by an act done at a time when, or in pursuance of arrangements made at a time when: (a) it is not possible by reasonable inquiry to ascertain the identity of any of the persons referred to in s.13B(2)(a)–(d) (persons by reference to whose life the copyright period is ascertained), and

(b) it is reasonable to assume:

(i) that copyright has expired, or

(ii) that the last to die of those persons died 70 years or more before the beginning of the calendar year in which the act is done or the arrangements are made.

(2) Subsection (1)(b)(ii) does not apply in relation to:

(a) a film in which Crown copyright subsists, or

(b) a film in which copyright originally vested in an international organisation...

Attributor: provides content tracking tools that can be used by publishers to detect piracy. www.attributor.com.

iCopyright: provides tools to embed in content which can automate rights, permissions and track content usage. http://info. icopyright.com. This US-based service claims to have 'invented instant licensing of digital content'.

Note: it is necessary to jump through all of these hoops if you are UK-based because we have no copyright registry; however, for jurisdictions that do have such a centralised copyright office, obviously try them first, e.g. in the US: www.copyright.gov.

Google Alerts can be used to request reports every time the title of your book comes up on the internet. Google updates every 24 hours and was used successfully by Christopher Priest to track copies of his novel *The Affirmation* (source: Society of Authors). www.google.com/alerts

INFORMATION BANK

[1] July 2010, Publishers Licensing Society Annual Copyright Meeting 13 July 2010.

For up-to-the-minute high level debate on these issues (orphan works/out-of-print), sign up for the Author's Rights bulletin: www.authorsrights. org.uk

See also Society of Authors; Quick Guide to Permissions: http://www.societyofauthors.org

See also Chapter 15, Table 15.2 'works of unknown authorship', p.114.

11

Pictures Speak Louder than Words: Still images and photography

'Special considerations attach to photographs in the field of privacy. They are not merely a method of conveying information that is an alternative to verbal description. They enable the person viewing the photograph to act as a spectator, in some circumstances voyeur would be the more appropriate noun, of whatever it is that the photograph depicts. As a means of invading privacy, a photograph is particularly intrusive. This is quite apart from the fact that the camera, and the telephoto lens, can give access to the viewer of the photograph to scenes where those photographed could reasonably expect that their appearances or actions would not be brought to the notice of the public.'

Douglas v Hello! Ltd (No 3) [2006] QB 125 at [84], *per* Lord Phillips of Worth Matravers MR for the Court of Appeal[1]

In this chapter I will mainly discuss copyright law. However, because photographs are so powerful in terms of grabbing the public's attention, and their ability to reveal intimate and personal information about a subject, they are protected by many different areas of the law, not just copyright. Privacy, human rights law, data protection[2] and the Press Complaint Commission's Code all come into play too, so be very wary of using photographs without permission.

Copyright law protects still images and photography separately from text and sound or audio-visual content. This chapter focuses on photography.

Myth: Photos are 'not creative enough' to warrant copyright protection	Wrong. There is no question that photographs are covered by copyright law. Indeed, you should assume that any photograph is protected by copyright, regardless of artistic merit – as long as it is original. From Annie Liebovitz and the output of professional fine art and advertising photographers, to the pictures taken by journalists, paparazzi and the man – or woman – in the street.

Only if a photograph has been taken using no skill and effort whatsoever, perhaps using some form of mechanical means, such as a photocopier, enlargement facility or CNC (Computer Numerical Control) machine, will it not be protected by copyright in itself as distinct from the object it shows. But even that category may be protected.[3]

Always expect that a photograph will have its own copyright separate from the item it is a photograph of. A painting has to be represented in a book or magazine in photographic form: someone has photographed or scanned the image, but separate copyrights exist for the original art work itself, and for each and every subsequent 'copy' of it in the form of photography.

Likewise, stills of television images are protected over and above, and separately, from the television programmes from which they may have been edited: see s.17 of the 1988 Act.[4] (But not if incidentally included.)

The person who commissions an artwork does not possess its copyright – the copyright is the creator's. That is the default position. This means that if you use freelance photographers (or designers or illustrators) they must assign their copyright to you in writing as publisher, before, not after, the event.

Don't forget: moral rights too

The artists and photographers have moral rights under copyright law too, and so can seek damages if they feel that there had been, for example, 'derogatory treatment' of their work, even if they have licensed economic copyright to someone else. So, for example, if a publication does not credit the photographer's name next to the image, or if the picture is used inappropriately – perhaps on merchandising which the photographer considers to be shoddy and which causes him to fear that its existence for sale would undermine his reputation – the photographer can seek a legal remedy (getting the item 'pulled', or damages, or both). Photographs commissioned for private purposes are also protected by moral rights.

Commissioned photographs

Copyright **always** belongs to the photographer, unless:
- There are any special circumstances which would make a court believe the commissioner had rights (applying trusts law). This is unusual, and it is probably not possible in Scotland.

• The photographer licenses or assigns copyright either in part, or entirely, to another or others.

Note: even if he assigns copyright, the photographer may still retain moral rights.

What can go wrong/ 'digitisation'

Digitisation enables the diffusion of images that may not have been pre-planned. Common DRM (digital rights management) tactics for avoiding unlawful dissemination of digital pictures include making available only low resolution images, using thumbnails only, watermarking, tagging or overlaying a blank so that if someone tries to cut and paste from a website or database, they just get the blank and not the underlying image (for example, this is what you get automatically if you use a website builder tool such as iWeb).

New sites and digital management tools crop up every day to try to help copyright owners to tag and easily license their works online. But the technology still seems weak and inadequate compared with the force of the internet and its natural drive to 'copy' and promulgate a myriad of 'secret' data 'clouds'.[5]

Wedding photographs

Wedding photographs nicely illustrate many of the issues surrounding copyright and artistic works in general, and photographs of people in particular. I have also noticed that, for whatever reason, wedding photos are often the catalyst for legal actions.

The exception for fair dealing on the grounds of current affairs reporting does not apply to the use of photographs.

'Vindictive damages'

Sometimes the courts want to make an example of people. This happened in 1960 to wedding photographer Frank Settle. The Court of Appeal decided to punish him by awarding exemplary damages against him for his part in selling a photograph to the papers for the sum of £15. For his troubles he was fined £1,000 and ordered to pay the claimant's costs.

Settle had been the wedding photographer for Mr and Mrs Williams. Two years after her marriage Mrs Williams's father was murdered, an event covered in the newspapers. The news stories were accompanied by one of her wedding photographs, showing her with her husband, father and other family members.

In those days, under the 1956 Copyright Act, copyright belonged to the person who commissioned the photograph, Mr Williams (even though his father-in-law, the murder victim, had paid for them). In Court, Settle argued unsuccessfully that he had an 'implied' licence to hand over the pictures to the *Daily Express* and *Daily Mail*. He also failed in his argument that he had offered the photograph to the papers on the basis that they promised to crop out the deceased man and not include other family members.

So, why did Mr Williams sue the photographer and not the newspaper? Surely the newspaper's pockets would have been deeper? Williams clearly felt betrayed by the photographer, and the Court of Appeal took on the full weight of his disgust. Mr Justice Willmer expressed his views as follows, in language not unknown to the redtops in question:

'It is difficult to find language strong enough to describe this grossly offensive behaviour on the part of the two newspapers. Even when it takes its most merciful possible form, the very sudden death of those nearest and dearest to us is a most appalling shock, as I can testify from recent personal experience. What it must be to be informed suddenly that your father or husband or father-in-law has been murdered I tremble to think. It was on top of this that these newspapers chose to blazon this picture of a happy occasion of a few years ago. Anything more calculated to wound and hurt bitterly the feelings of all members of the family I can hardly conceive.'

The then Press Council fined the *Daily Express* £52 10s, damages and costs and the paper also had to apologise to Mr and Mrs Williams.

People shots

Nowadays the paper would surely also be in court. It used to be the case that, since photographers owned the copyright in their photographs (post-1 August 1989 anyway, see previous

paragraph), no one could prevent the use of photographs of themselves unless they were taken in private.[6] The incorporation of the Human Rights Act into English law in 2000 changed this. Now, it is not only celebrities such as Catherine Zeta Jones, Naomi Campbell and Elizabeth Jagger who have an expectation of privacy – 'ordinary' people do too. You are safest to ask the subject of the photograph for permission before publishing it; and you must ask the parent or guardian if the subject is a child, for privacy and data protection as well as copyright reasons. Model release forms[7] are the best way to do this. If you feel you can dispense with the subject's permission: think twice and ask for legal advice.

See also the case report in Chapter 9, 'Criticism or Review' and 'Incidental Inclusion', on fair dealing defences and the Piers Morgan/Victoria Beckham photographs case.

Facebook

Use of photographs from the Facebook website could well breach copyright (although, by uploading their images to the site, in the absence of any published restrictions, and by implication, users might be said to have waived their rights and in effect 'given the pictures away'). You could also run into trouble with the Press Complaints Commission's Editor's Code of Practice, particularly if the use made of the images is intrusive. The PCC recently ruled that a *Scottish Sunday Express* article headlined *Anniversary shame of Dunblane survivors*, published in on 8 March 2009, intruded into the private lives of three families in breach of Clause 3 (Privacy) of the Editors' Code of Practice.[8]

INFORMATION BANK

[1] Lord Phillips of Worth Matravers continues: 'The intrusive nature of photography is reflected by the various media codes of practice. It is also recognised by the authorities. In *Theakston* v *MGN Ltd* [2002] EMLR 398 Ouseley J refused an injunction restraining publication of a verbal depiction of the claimant's activities in a brothel. He granted, however, an injunction restraining the publication of photographs taken of these activities.'

[2] When the *Sunday People* published naked and semi-naked photographs of Radio 1 DJ Sara Cox and her then husband DJ Jon Carter honeymooning on a private island, the couple pursued a legal claim under data protection laws (ss.13 and 14 of the Data Protection Act 1998) and the common law duty of confidence. They were particularly upset by the fact that the illicit photographs, published under salacious tabloid headlines, gave the impression to the public that they were co-operating with the photographer (who was using a telephoto lens). The couple won £50,000 plus costs for the manifest and gross invasion of their privacy and sought delivery up and destruction of all copies of the images taken. *Cox* v *MGN Ltd* [2006] EWHC 1235 (QB) (trial in April and May of 2006, after the couple had split).

Clandestine recording, visual or audio, is governed by the Press Complaints Commission (PCC) Editors' Code, Clause 10.

[3] See further my analysis of the Bridgeman Art Library case in *Copyright for Artists, Designers and Photographers*, Chapter 5. *Bridgeman* v *Corel* basically says that in the US 'mechanical' or 'slavish' copies do not have copyright protection; but under UK law they probably do.

[4] Section 17 of the 1988 Act: Infringement of copyright by copying.
… '(4) Copying in relation to a film [or broadcast] includes making a photograph of the whole or any substantial part of any image forming part of the film [or broadcast].'

[5] Initiatives like PLUS (Picture Licensing Universal System) and Ozmo.com (a content licencing website) may help in future, but at the time of writing are either in beta (testing) mode or are limited to US users.

[6] See s.85 of the Copyright, Designs and Patents Act 1988, which applies to photographs commissioned 'for private and domestic purposes' and prevents the exhibition, 'communication to the public' and 'issuance to the public' in those copyright photos (unless incidentally included).

[7] Model Release Forms (Adult and Minor): see Professional Photographer: www. professionalphotographer.co.uk/Magazine/Downloads/Model-Release-Form

[8] www.pcc.org.uk/cases/adjudicated.html? article=NTc5Mw==

12

Libel and Privacy

By Ian Bloom, Ross & Craig Solicitors

> 'Reputation, reputation, reputation! O! I have lost my reputation. I have lost the immortal part of myself, and what remains is bestial.'
> William Shakespeare, *Othello*, Act II, Scene iii.

'Defamation' is nothing to do with copyright, but this book would be incomplete if it did not at least mention defamation, since, as we are constantly hearing, a superinjunction can be much deadlier for writers and their publishers than copyright disputes.[1]

The question of privacy and the public interest has, in the last few years, raced up the charts in terms of legal actions begun. However, there is a specific copyright angle relating to privacy, as we will see below.

What is an injunction anyway?

- 'standard' injunctions: the claimant who obtains the court order can be named, but the subject matter kept secret
- 'super' injunctions: even disclosing the existence of the order, let alone revealing the identity of the individual who granted it, is prohibited.

Libel

To succeed in an action for defamation the injured party needs to prove three things:

1 that the words complained of are defamatory;
2 that the person aggrieved by the words will believe that they refer to him;
3 that there was actual publication. (That is, the words complained of were seen by more than [just] the claimant.)[2]

If a person can show in court that defamatory words were published which refer to him, and he sues within a year of first publication, he starts the legal process. Articles in the Press are the

usual suspects, but letters, emails and blogs count too. Indeed, in 1997, some staff at Norwich Union Healthcare reputedly caused their employers to be sued £450,000 because they exchanged defamatory emails about the financial strength of rival company, Western Provident Association.[3]

Although the Defamation Bill 2011 is not (yet) an Act of Parliament, one of its key recommendations has widespread support and is likely to amend the Defamation Act 1996. At present, each repeat (including a 'retweet') of a libel on the internet 'counts' as a new publication. Since so much that is published on a daily basis is also available online, newspaper editors and publishers cannot easily be protected from claims being made regarding stories that first appeared years ago but remain accessible on the internet. So the rule that requires a claimant to sue within one year of publication of the offending piece (reduced from three by the 1996 Act) can be sidestepped. This is bound to change. One year will soon mean one year from first publication (this should reduce the number of deletions made by the more cautious newspaper lawyers to online archives every time a claim is made).

Defences

The defences to an accusation of libel are:
- 'privilege';
- 'justification' (what has been said is the truth); and
- 'honest comment'/previously known as 'fair comment'[4] (what was said was said in good faith and without malice).

The easiest defence to describe is that of 'privilege', which is divided into two parts. **'Absolute' privilege** protects what is said in Parliament by legislators and subsequently accurately reported (e.g. in Hansard), from legal proceedings.

'Qualified' privilege enables defendants who publish defamatory material to claim that they had a legal, social or moral duty to publish, and that their readers had a corresponding interest in it. They were entitled as a matter of public policy to run a 'public interest' defence. (What constitutes 'public interest' is in itself controversial, and has been the subject of legal scrutiny in cases involving Naomi Cambell, George Galloway and those mentioned below.) This defence found favour recently in the House of Lords (now the Supreme Court) when the Court acknowledged that if:

> '...the publisher... has taken such steps as a responsible journalist would try to take and ensure what is published is accurate and fit for publication (then) weight should ordinarily be given to the professional judgment of an editor or journalist in the absence of some indication that it was made in a casual, cavalier, slip-shod or careless manner.' *Jameel v Wall Street Journal Europe* [2006] HL.

This leading case reinforced the earlier decision in *Reynolds* v *Times Newspapers Limited* when the House of Lords for the first time tried to define what responsible journalism actually amounted to. The burden of proof remains with the defendant to demonstrate the care it took not to publish defamatory statements.

Perhaps the most dangerous defence is that of **'justification'**. The defendant, in effect, accepts the gauntlet thrown down by the claimant and says that he will prove that his claims are not defamatory because they are true. The *Guardian* newspaper famously risked this defence when Jonathan Aitkin sued it for libel. In an age when full disclosure of relevant documents and the exchange of detailed witness statements prior to trial are the norm, it is unusual for rabbits to be produced in the courtroom from the wigs (never mind the hats) of the parties' QCs. But on this occasion, the dramatic last-minute production of receipts from a Parisian hotel fatally undermined Jonathan Aitkin's claim for defamation. He lost his case and was later imprisoned for perjury. Memorably, some years earlier, Jeffrey Archer suffered the same fate.

The final defence is that of **'honest comment'**. The principal feature of an 'honest comment' defence is that what was printed was an opinion, published in good faith and without malice. **In these circumstances, the Press are given the benefit of the doubt since not every inaccurate statement will be treated as defamatory.**

Business defamation

In *British Chiropractic Association* v *Singh* (2010) the claimant, a corporation known as the British Chiropractic Association (the BCA) contended that it was defamed by the defendant, Dr Simon Singh, a scientist and writer. On the Comment and Debate page of the print and electronic editions of *The Guardian* on 19 April 2008 Dr Singh published an article which included this passage:

'The British Chiropractic Association claims that their members can help treat children with colic, sleeping and feeding problems, frequent ear infections, asthma and prolonged crying, even though there is not a jot of evidence. This organisation is the respectable face of the chiropractic profession and yet it happily promotes bogus treatments.'

Mr Justice Eady held that, to a reasonable reader, these words would mean:

(1) That the BCA claimed that chiropractic was effective in helping to treat children with colic, sleeping and feeding problems, frequent ear infections, asthma and prolonged crying, although it knew that there was absolutely no evidence to support its claims.
(2) That by making those claims the BCA knowingly promoted bogus treatments.

He went on to hold that these were assertions of fact, not expressions of opinion. As such, Dr Singh at trial must prove that the meanings are factually true or lose.

On appeal, the Court of Appeal concluded that Mr Justice Eady erred both in conflating these two elements of the claim and in treating the first of them as an issue of verifiable fact. In the view of the Court, the single issue posed by the judge was in reality two distinct issues:

(1) Was there any evidence to support the material claims?
(2) If there was not, did the BCA's personnel know this?

If, as Dr Singh has contended throughout, the first issue is one of opinion and not of fact, the second issue ceases to matter.

The result of the Court of Appeal ruling was that BCA withdrew its lawsuit to avoid incurring further legal costs. Some see the case as showing that the courts will not (now) allow defamation lawsuits to be used as a cover to silence legitimate criticism.

Offer of amends

Milne 'No matter how imperfect things are, if you've got a free press, everything is correctable and without it everything is concealable.'

Ruth 'I am with you on the free press. It's the newspapers I can't stand.' Sir Tom Stoppard, *Night and Day* (1978), Act 1

The offer of amends is, in effect, an offer of settlement. It must be in writing and made before any defence to a libel claim is served.

And in practice? Say a tabloid publishes a story about a celebrity and gets some of the details wrong. The celebrity has some grounds for complaint. The newspapers' lawyers are now able to use section 2 of the Defamation Act 1996 to say, 'A-ha! We may have got it wrong, but this libel is in our view 'worth' only £30,000. So we are going to offer you, Mr Celebrity, £15,000 now (an offer of amends carries a tariff of around a 50 per cent reduction from the likely damages award), plus a published apology if you drop the action. If you don't agree, we will go to trial and hit you for our costs if, at the end of the trial, the judge agrees that our offer of £15,000 was reasonable. By then you will have spent a load of money on your own lawyers – and the good news for us is that you'll have to pay ours as well...'

Privacy

'They come together like the coroner's inquest, to set upon the murdered reputations of the week.' William Congreve, *The Way of the World* (1700), Act 1, Scene i

Whereas the whole point of an action for defamation is to seek damages from the publisher of a defamatory statement after publication, a claimant in a privacy action is normally concerned with trying to prevent that which is true from being published in the first place. He is trying to keep the genie in the bottle. As the prospects of successfully injuncting the Press to prevent them printing untruths have declined in recent years, so the willingness of judges to grant injunctions to protect the reputations of (normally) the rich, and (usually) the famous from embarrassing disclosure has risen. This, in turn, has fuelled a bitter controversy in the Press (and subsequently in Parliament) with the majority of newspaper editors and journalists expressing alarm at the courts' preference for the privacy rights of the individual, under Article 8 of the Human Rights Act 1998, over those rights which confirm the freedom of the Press, enshrined in Article 10 of the same Act.[5]

Mosley v *News of the World*

This controversy really began when Max Mosley sued the *News of the World* (*Mosley* v *Newsgroup Newspapers Limited* [2008]). The trial judge, Mr Justice Eady, for many years the leading media law judge in the High Court in London, decided that Max Mosley's

privacy had been invaded by the *News of the World*'s front-page story headlined: 'F1 Boss had Sick Nazi Orgy with 5 Hookers' in March 2008. The lurid description of Mr Mosley's private sado-masochistic activities was spread over several inside pages and was accompanied by a short video available online. The newspaper claimed that they were entitled to breach Mr Mosley's privacy because the public's 'right to know' (he was, at the time, President of the FIA [*Fédération Internationale de L'Automobile*]) trumped his privacy rights.

The High Court decided otherwise. Not for the first time, Mr Justice Eady said the words that have been repeated endlessly ever since: '**... what engages the interest of the public may not be material which engages the public interest**'. He awarded Mr Mosley £60,000 in damages for breach of privacy and £420,000 in costs. Mr Mosley was still out of pocket. The *News of the World* did not appeal the decision, but Mr Mosley's subsequent application to the European Court for a ruling that newspapers must provide advance notification to anyone whose privacy they proposed invading was dismissed. Whilst the judges were sympathetic to his claim, they could not easily establish a workable, operational framework for such restriction on Press freedom to be made compulsory.

Out of the Mosley case and the perceived willingness of the High Court to favour privacy rights arose a slew of injunctions banning a frustrated, usually tabloid, Press from allowing usually attractive young ladies to sell their stories about their relationship(s), however fleeting, with celebrities (usually footballers). The facts of each case, which were carefully balanced by the judges, were largely ignored by those tabloids, unwilling to accept that the privacy rights of any wayward celebrity (or, more to the point, his wife and young children) would be invaded by Press disclosure. The occasional suspicion that blackmail might be a factor ('Give me £50,000 or the story will be in the newspapers') was also overlooked by newspapers impatient with anyone in the public eye who they considered had forfeited their right to privacy by putting aspects of their life into the public domain.

Social media

The privacy issue has always been complicated, but the rise of social media (Facebook and Twitter in particular) has made it even more so. Judges make such orders as they consider

appropriate having heard the evidence. However, with limited exceptions, their powers of enforcement end at the borders of this jurisdiction. So if you live in Scotland or America, or in fact anywhere but England and Wales (and even if you live in these parts of the UK, all you need is access to anonymity on Twitter or Facebook), you may be in a position to publish the identities of those names the High Court has ordered be kept secret. But if you do publish, in contempt of a court order of which you are aware that bans such disclosure, you may still be dammed if the court seeks to make an example/martyr of you.

The rise of the internet in the last 15 years has democratised communications to a previously unimaginable extent. Direct action is now not merely an option but practised on a mass scale. It is no longer possible to keep secrets secret by judicial order alone.

Copyright and the social media

Journalists and researchers investigating stories find an extraordinary amount of private information on social network sites. Facebook, MySpace and YouTube users regularly upload detailed personal accounts, together with photographs. Photographs in particular can be 'lifted' from Facebook sites and re-published. Invariably, no permissions are sought, let alone obtained. Publication on a social network site does not, of itself, put a photograph into the public domain such that it can be used freely without payment, let alone attribution.[6] Since the copyright in the photographs belongs (in almost all cases) to the original 'poster', unauthorised reproduction represents an actionable breach of copyright. It is difficult to see any defence to an action for infringement defeating a claim for breach – even though the damages awarded may be insignificant. Similarly, copying chunks of personal information intended for limited circulation between friends does not entitle wholesale reproduction by a tabloid newspaper. It is ultimately the responsibility of the 'poster' to ponder issues such as: are they acting deliberately; have they applied appropriate privacy settings; have they added copyright notes; do they have any interest in seeking redress; or indeed are they wise to publicise themselves in this way in the first place?

Interesting fact Defamation is all about protecting someone's reputation: note therefore that there is a certain amount of cross-over legally between defamation and moral rights. The moral rights that an author has to guard against – 'false attribution' and 'derogatory treatment' of a work – have been available as statutory rights since 1989 (i.e. since the enactment of the Copyright, Designs and Patents Act 1988), but similar-fact situations were dealt with prior to that by other parts of the law (e.g. libel).

INFORMATION BANK

This chapter was written at the end of May 2011.

[1] Slander, the spoken form of defamation, is rarely an issue.

[2] 'Publication' means that the statement is communicated to at least one person other than the subject. It would include letters, emails, and comments posted on a public noticeboard: *Slipper* v *BBC* [1990] All ER 165.

[3] *The Times*, 18 July 1997

[4] The defence of 'fair comment' was redefined by the Supreme Court late in 2010, and is now 'honest comment'. The case involved a former Mowtown tribute band called The Gillettes, and the Supreme Court overturned the ruling.

[5] For Articles 8 (Right to respect for private and family life) and 10 (Freedom of expression) of the European Convention on Human Rights see Schedule 1 to the UK Human Rights Act 1998: http://www.legislation.gov.uk/ukpga/1998/42/contents

[6] By posting your photos on Facebook and similar sites you are likely to be tacitly granting the website (i.e. Facebook, as opposed to other people) permission to use the photos in ways set out in their Terms and Conditions. If this concerns you, you should find and read them.

There are several excellent, if expensive, textbooks on defamation currently in print.

Gatley on Libel and Slander (11th edn) (London: Sweet & Maxwell, 2010). Edited by a quintet of serious legal experts, this volume is exhaustive.

Price, David, Duodu, Korieh and Cain, Nichola, *Defamation – Law, Procedure and Practice* (4th edn) (London: Thompson/Sweet & Maxwell, 2009). Very user friendly.

The best recent privacy book is the magisterial Tugendhat & Christie, *The Law of Privacy and the Media* (Oxford: Oxford Univeristy Press: 2010).

The best short guide, a 98-page booklet, is harder to obtain. Whittle, Stephen and Cooper, Glenda, *Privacy, probity and the public interest*. (Oxford: Reuters Institute for the Study of Journalism, 2009)

Mathieson, Keith, *Law Society Privacy Law Handbook* (London: The Law Society, 2011). Also useful.

13

Journalists and Newspaper Editors

Reporting

Copyright protects the expression of ideas, as soon as they are actually 'expressed' – handwritten, typed or recorded on a device or spoken on the telephone. Copyright applies to note-form jottings of speeches and live events. If two reporters made notes simultaneously of an identical speech or event, two separate copyrights arise in the two sets of notes (presumably slightly different but technically for copyright law they need not be different, just independently created); and then again more copyrights come into existence in any edited and published accounts of the event.

If you are interviewing, copyright in the interviewee's words belongs to the **interviewee**, but – and this is a little strange as a concept and some mental gymnastics are required – it takes your act of writing or recording the words (creating a 'record' of the scripted or non-scripted words) to give birth to the copyright. You should, therefore, ask permission to reproduce any quotes later in your writing or broadcast unless certain conditions apply, as detailed in s.58 of the 1988 Copyright, Designs and Patents Act.[1] If you then publish or broadcast the record, another copyright is created belonging to the publisher or broadcaster.

Transcripts **probably** enjoy their own copyright too, provided some degree of skill and labour has been expended in taking down the words – law reporters who transcribe court judgments are undoubtedly exercising high levels of skill; similarly with Hansard reporters, for example. But there is some doubt over this point. To read an excellent academic analysis of why verbatim transcribers are not copyright 'authors' see Justine Pila's excellent article in the *Modern Law Review*.[2]

So, if a written transcript is provided to a newspaper and published verbatim, as a direct, first record of current events, then its use is likely to be permissible: no third party's copyright

will block its use unless the speaker has vetoed or embargoed its publication or the use was not of the kind which has been previously agreed. The Queen was able to take legal action in 1992 against *The Sun* on these grounds when the paper released her embargoed Christmas Day message early. Likewise HRH the Prince of Wales used copyright law to object to the exposure of his unpublished words (albeit that they were first written eight years earlier), see below.[3]

Query: what about surreptitious recordings of speeches? *McNae's Essential Law for Journalists*[4] says that these will not be in breach of the speaker's copyright *per se*, but that the speaker will own the copyright once the record is made. By implication, if a record was made surreptitiously, while it has not been specifically vetoed, it has not been authorised either, so you would fall foul of s.58.

Speeches

No copyright arises until words are expressed in a permanent form. So, if an after dinner speech is spoken and heard, there is no copyright in the spoken words; but if it is recorded (in audio, by visual means or in writing) a copyright comes into existence and to republish without permission could be a breach of that copyright. So if you are anxious to protect the exclusivity of content, it is safer to record the speech in a fixed form.[5] And even safer still to mark the content as 'confidential' and 'secret'[6] information.

Foreign language translations always get their own copyright separate from the original text. Note, however, that an author's own exclusive right to adapt his own work could also apply to his translating that work (s.21).[7]

Speeches: the caselaw

Speeches are difficult area in copyright. Basically, copyright will protect a speech when it is 'expressed' or transcribed or reported, as above. It does not matter if the transcription is literal, with no creative or literary input (i.e. just a straight reporting of words); or whether it is written down by the speaker/author herself with all the talent, expertise and training she brings to the job. The act of expressing it in a fixed form gives it copyright. That is old law which still stands, but there is an academic argument that this is wrong, and based on a misunderstanding of what the copyright legislation post-1911 was supposed to protect.

Table 13.1: Copyright in speeches and transcripts: an academic debate

Yes, copyright applies to the skill of transcribing a speech	No, no copyright is granted to a straight, verbatim transcriber because she is not an author and her output is not a 'book'.
Walter v *Lane* majority	*Walter* v *Lane* minority view Lord Robertson and Justine Pila citing *Interlego* case.

The misunderstanding is one which keeps cropping up throughout copyright cases: not just the ones on literary copyright or the ones on speeches. It is something to do with a misunderstanding about the separation of ideas versus expression: see Chapters 3, No Copyright in 'Ideas'? and 5, 'Substantial Copying'. Copyright attaches to the expression not the idea itself, as we have seen; *but* there are lots of times when it is not so straightforward.

As always with copyright, it is best to assume something is protected by copyright and ask permission for any re-use. Err on the side of caution.

Journalism and the fair dealing defences

Paddy Ashdown v *Telegraph Group* (Court of Appeal)

This case concerned verbatim quotes from leaked material (Paddy Ashdown's (PA) Minute of a closed confidential meeting with the Prime Minister. *The Sunday Telegraph*'s defence of fair dealing was not successful in court. The High Court granted PA an interim injunction to stop further infringement by the newspaper and allowed further arguments to enable PA to elect either damages or an account of profits. PA's claim that his human rights had been breached (on the freedom of expression ground) failed before the High Court but was successful in the Court of Appeal. An argument by the paper that there was a public interest to be served in disclosing the material at the core of the case had potential but was ultimately not successful because of the quantity of material used.

What the paper published

A cover story, a lead feature across pages four and five containing several verbatim quotes from the document, and an editorial comment. PA was successful in his legal action against the newspaper.

Fair dealing arguments

Section 30 (1) fair dealing for criticism or review (1988 Act)

The Court of Appeal found that the newspaper's use was NOT for the purposes of criticism or review. It was criticism or review of the actions of the Prime Minister and PA but not criticism or review of the actual leaked document. So it follows that to say you are repeating or reporting a source for the purposes of criticism or review you need to be criticising and reviewing the actual source document, not general surrounding events or issues.

This appears to contradict what was said in the *Clockwork Orange* case, see Chapter 9, 'Criticism or Review' and 'Incidental Inclusion'.

Section 30 (2) fair dealing for current affairs news reporting

The newspaper's use could, in principle, have been defended as current affairs news reporting but it was damaging to the paper's defence that:

1 Its reports were commercially competitive with PA's own publications. This appears to have been the most damaging factor against the paper: its publication of the stories could have interfered with the copyright owner's (PA's) exploitation of the work.

2 The quantity of material taken from the source was substantial, not a little (note that quantity does matter here, in the context of the copyright defence; but quantity is not the measure of copying in itself, see Chapter 4, 'Substantial Part': Too close for comfort – quality not quantity).

3 The material reported was not already in the public domain and the courts did not look favourably on the use of leaked information as a matter of general principle.

Interesting asides

- freedom of expression protects the right both to publish information *and to receive it*
- the taking of a large quantity of the source material could prevent a defence of fair dealing, *but so could the regular taking of little bits.*[8]

Note: the exception for fair dealing on the grounds of current affairs reporting does not apply to the use of photographs.

HRH Prince of Wales v Associated Newspapers Ltd

The same two fair dealing defences also failed to help Associated Newspapers in a not dissimilar case involving the *Mail on Sunday* and the private journals of His Royal Highness the Prince of Wales.

In 2005 the newspaper published passages from the Prince's travel journals, including passages of text in which he made disparaging comments about officials during his 1997 visit to Hong Kong and the handover of Hong Kong to China. The handwritten journals had been circulated to select personnel in an envelope marked 'private and confidential' but had been leaked to the press.

The Prince argued for primary infringement of copyright: copying and issuing to the public under s.17 of the 1988 Act. He also argued for secondary infringement: possession by the paper of the material in the course of its business without the copyright owner's consent, knowing it to be unlawful (s.23). The case also involved breach of confidence.

The paper argued that the copying was not unlawful because it was not substantial copying; that it was in any case fair dealing either as the reporting of current events (even although eight years after writing the diary entry, the report could be seen to be relevant to the Prince's failure to attend a banquet at Buckingham Palace for the Chinese state visit); that it was fair dealing for criticism or review; and/or it was in the public interest to publish.

The newspaper lost the case. The judgment is long and complex but for present purposes it is perhaps most useful to highlight the importance of breach of confidence (as opposed to copyright) for this trial; and to say that the defence of fair dealing for criticism or review (s.30 (1)) was knocked out because the material had clearly not been made available to the public before: see s.30, as follows:

Section 30 **Criticism, review** **and news** **reporting**	(1) Fair dealing with a work for the purpose of criticism or review, of that or another work or of a performance of a work, does not infringe any copyright in the work provided that it is accompanied by a sufficient acknowledgement **and provided that the work has been made available to the public.** (1A) For the purposes of subsection (1) a work has been made available to the public if it has been made available by any means, including: (a) the issue of copies to the public; (b) making the work available by means of an electronic retrieval system;

(c) the rental or lending of copies of the work to the public;

(d) the performance, exhibition, playing or showing of the work in public;

(e) the communication to the public of the work,

but in determining generally for the purposes of that subsection whether a work has been made available to the public no account shall be taken of any unauthorised act.

(2) Fair dealing with a work (other than a photograph) for the purpose of reporting current events does not infringe any copyright in the work provided that (subject to subsection (3)) it is accompanied by a sufficient acknowledgement.

(3) No acknowledgement is required in connection with the reporting of current events by means of a sound recording, film (or broadcast where this would be impossible for reasons of practicality or otherwise).

See also Chapter 9 on fair dealing defences, and Chapter 11 on pictures.

Freelancers/ commissioning editors

If a freelance writer sends a speculative feature to a publication, the copyright remains with the freelancer until the publisher secures a grant of copyright (licence or assignment).

The publisher will want all rights, an assignment preferably; the freelancer if he has negotiating power, will want to minimise the 'rights grab' and offer limited use – and will only sign a licence not an assignment. It's a business deal so it may involve a tussle.

If the freelancer has not signed any copyright deal and the article is published anyway, the freelancer will have the legal right to pursue the publisher for primary infringement of copyright, and may have a moral rights' claim too depending on whether the writer's name is used. An offer of a feature on spec is probably not covered by the 'implied licence to publish once' situation, mentioned in relation to the letter to the Editor in Chapter 2, How Issues can Crop Up.

It is a difficult area therefore for freelancers where an article written and submitted by them on spec later appears in print, in slightly rewritten form. There is no copyright in ideas or news so if somebody else rewrites your 'story' you may not be able to do anything about it. There could however be issues of plagiarism the freelance writer could pursue. Staff journalists write in an 'employment' context, and so copyright in their work is always likely to belong to their employers.

INFORMATION BANK

[1] **Section 58: Use of notes or recordings of spoken words in certain cases**

(1) Where a record of spoken words is made, in writing or otherwise, for the purpose
 (a) of reporting current events, or
 (b) of communicating to the public the whole or part of the work,

it is not an infringement of any copyright in the words as a literary work to use the record or material taken from it (or to copy the record, or any such material, and use the copy) for that purpose, provided the following conditions are met.

(2) The conditions are that:
 (a) the record is a direct record of the spoken words and is not taken from a previous record or from a broadcast [...];
 (b) the making of the record was not prohibited by the speaker and, where copyright already subsisted in the work, did not infringe copyright;
 (c) the use made of the record or material taken from it is not of a kind prohibited by or on behalf of the speaker or copyright owner before the record was made; and
 (d) the use is by or with the authority of a person who is lawfully in possession of the record."

Query: so does this mean speakers can fully dictate how something is reported? The section certainly puts a lot of power into the hands of the speakers.

Note that this slightly conflicts with what Chancery Court said in *Donaghue* v *Allied Newspapers*, discussed in Chapter 3 (but the s.58 provisions are about a more specific point and would take precedence over the older case).

The leading case is *Walter* v *Lane* [1900] AC 539 which held that speech that is transcribed can produce two separate copyrights: one, the copyright of the speaker; and, two, that of the newspaper journalist who wrote it down.

[2] Justine Pila *An International View of the Copyright Work* (2008) 71(4) MLR 535-58.

[3] *HRH Prince of Wales* v *Associated Newspapers Ltd* [2008] Ch 57-128 (note the length of the judgment).

[4] Banks and Hanna, *McNae's Essential Law* (2009) p.459.

[5] Cornish, *Copyright in a Week* (2002).

[6] The word 'secret' does sound wrong and arcane but it is what is required by law.

[7] **Section 21: Infringement by making adaptation or act done in relation to adaptation**

(1) The making of an adaptation of the work is an act restricted by the copyright in a literary, dramatic or musical work.
 For this purpose an adaptation is made when it is recorded, in writing or otherwise.

(2) The doing of any of the acts specified in ss.17–20, or subsection (1) above, in relation to an adaptation of the work is also an act restricted by the copyright in a literary, dramatic or musical work.
 For this purpose it is immaterial whether the adaptation has been recorded, in writing or otherwise, at the time the act is done.

(3) In this Part 'adaptation':
 (a) in relation to a literary work, other than a computer program or a database, or in relation to a dramatic work, means:
 (i) a translation of the work;
 (ii) a version of a dramatic work in which it is converted into a non-dramatic work or, as the case may be, of a non-dramatic work in which it is converted into a dramatic work;
 (iii) a version of the work in which the story or action is conveyed wholly or mainly by means of pictures in a form suitable for reproduction in a book, or in a newspaper, magazine or similar periodical;

[(ab) in relation to a computer program, means an arrangement or altered version of the program or a translation of it;]

[(ac) in relation to a database, means an arrangement or altered version of the database or a translation of it;]

INFORMATION BANK

database or a translation of it;]

(b) in relation to a musical work, means an arrangement or transcription of the work.

(4) In relation to a computer program a 'translation' includes a version of the program in which it is converted into or out of a computer language or code or into a different computer language or code.

(5) No inference shall be drawn from this section as to what does or does not amount to copying a work.'

[8] Therefore, 'persistent lifting of facts from another paper, even if there is rewriting each time, may still be infringement because of the skill, labour and judgement that went into research on the [original] stories': Banks and Hanna, *McNae's Essential Law* (2009) p.447.

14

Moral Rights, Satire and Parody: Don't you 'shizzle my nizzle'

Moral rights belong to the artist/creator/writer. They are supposed to be less about property (intellectual property; real property), more about the *personality* of the creator. The idea is that writers invest in their work not only effort and labour ('sweat of the brow'), which must be economically compensated by the copyright system, but also a lot of themselves personally: their output may represent a huge personal endeavour and might involve/require talent (but not necessarily) so they are protected by the law in the form of moral rights – which centre on **reputation**.

It is often thought that whereas economic rights can be assigned or licensed, moral rights are 'perpetual' and 'inalienable'. Actually, while moral rights cannot be assigned to another person (because they are personal to the artist),[1] they can be bequeathed by Will, and they can be waived.[2] Indeed, writers are often asked to do so in contracts.[3] Moral rights exist *in addition* to economic copyrights: so you could begin a legal dispute with a publisher, for example, for being in breach of your copyright (e.g. the reproduction of a substantial part of your work without permission) *and* for breaching your moral rights in any of the ways described below. The lawyers' way of doing this might be to offer the court an 'and/or' choice: 'please find this publisher in breach of this author's copyright and/or in breach of her moral rights…'. It is also possible, and indeed common, to assign or license copyrights away to a third party, but to keep the moral rights for yourself, the author or creator.

UK law

The following specific moral rights have been enforced as law in the UK by statute (the 1988 Act) – the right to:

1 Be identified as author or director;
2 Object to derogatory treatment of work; and

3 To privacy of certain photographs and films (this overlaps with other privacy rights which attach to photographs of people: see Chapter 11, Pictures Speak Louder than Words: Still images and photography).

1. The right to be identified as author or director

For the UK right to be identified as author or director, see s.77 of the 1988 Act. This is the artist's right of 'attribution' (in other legal systems known as the right of 'paternity'), and it works both ways: it is the right for your name to appear with your work, but it is also the right to NOT have your name associated with work which is not yours (which would be 'false attribution').

Sawkins v Hyperion

The attribution of authorship must be in the exact form the author requires it to take, or at least be reflective of actual authorship. *Sawkins* v *Hyperion* is a musical copyright case involving a composer who transcribed the music of French 17th-century composer Lalande into new scores capable of being performed and recorded. Sawkins wanted record label Hyperion to use the legend '© Copyright 2002 by Lionel Sawkins' on a CD recording. It did not and used instead the acknowledgement 'With thanks to Dr Lionel Sawkins for his preparation of performance materials for this recording'. The Court of Appeal found in favour of Sawkins and held the acknowledgement to be inadequate because it did not convey authorship in the work.

And for this right to kick in, the artist must have signed the work or must 'assert' that right (s.78), in words such as these:

- *'the right of Gillian Davies to be identified as the author of this work has been asserted in accordance with ss. 77 and 78 of the Copyright, Designs and Patents Act 1988'.*

Christoffer v Poseidon Film Distributors

TV script writer Andrew Christoffer (C) and his co-writing brother claimed that they were the authors of six scripts for animated children's programmes called *Global Bears Rescue*, and that three of their scripts were made into animated films and shown on television, but that the credits at the beginning and end of the films did not identify them as authors, giving them an arguable case under s.77 of the 1988 Act. One of the films even credited

another writer. However, the High Court dispatched the matter very easily by saying that as the authors had not asserted their attribution right either 'generally' or 'specifically' – the s.77 claim failed on the grounds of s.78(2).

This author/director provision does not apply to computer programs; typeface designs; computer-generated works; or works produced by employees; and it will not apply if 'incidental inclusion' applies, nor if fair dealing/current affairs news reporting applies, nor if you have agreed to include the content in a magazine or book. See s.79. It also does not apply to works where the author died before 1 August 1989.

2. Derogatory treatment (also known as the right of integrity)

The right to object to derogatory treatment of your work (s.80) can apply, for example, to the cropping of photographs; merchandising/overprinting images with text; placing images in inappropriate contexts; stretching or distorting of graphics etc. It might cover situations where text is placed in an inappropriate context (see the Alan Clark case on the facts, below, although moral rights were not argued in that case).

This is similar to the French right of integrity.

So for example, according to a press report, Samuel Beckett once tried to put a stop to the first New York production of a theatre piece on the grounds that a stage direction had been violated.[4] And Beckett's estate continues to monitor his moral rights on the deceased playwright's behalf: stopping Deborah Warner, whose production of the 20-minute *Footfalls* was playing to sell-out audiences at the Garrick Theatre, London, in 1994 – because of two instances of a small number of lines purposely reassigned, spoken not by the ancient mother (who is present in the play just as a voice) but by her daughter. The Beckett Estate was able to intervene and ban the European tour and projected TV version of the play.

I have found no reported literary copyright case but readers may like to note the completely hilarious case from the world of musical copyright of *Confetti Records* v *Warner*.

Confetti Records v Warner

This case relates to a compilation CD including a rap remix of a formerly recorded and released song.

It is a tale of copyright licensing, contract law and the effect of the statement 'subject to contract' among other things (there were problems relating to two or three different recordings being released at the same time contrary to licensing agreements). It also involves the moral right of derogatory treatment, because a compilation recording was released using a recording of a piece of garage music which had been re-worked with the superimposition of rapping (by three different rappers-including the 'most offensive' rapping by Elephant Man, which may or may not allude to sex or drugs). In the event the Court found that the rap was unintelligible ('like a foreign language'), and that another track had been interposed into the original track. That all sounds like derogatory treatment to me but the Court found that the case for derogatory treatment failed: because the 'author' of the original song did not show that there had been **not only** derogatory treatment, but derogatory treatment ('distortion or mutilation') such as to cause him **personal prejudice or dishonour to his reputation** (applying Art 3*bis* of the Berne Convention). The hilarious bits of the judgment relate to Elephant Man's rapping contribution, as reflected in the bemused words of the Court of Appeal judge himself, Lord Justice Pill:

'The nub of the original complaint... is that the words of the rap (or at least that part contributed by Elephant Man) contained references to violence and drugs. This led to the faintly surreal experience of three gentlemen in horsehair wigs examining the meaning of such phrases as "mish mish man" and "shizzle (or sizzle) my nizzle.

'...The "author" in the present case is the third claimant, Mr Alcee. The assignment of his copyright to the first and/or second claimants does not affect his authorship. The first and second claimants are not entitled to complain of prejudice to their honour or reputation.

'...When played at normal speed the words of the rap overlying "Burnin" are very hard to decipher, and indeed the parties disagreed on what the words were. Even when played at half speed there were disagreements about the lyrics. The very fact that the words are hard to decipher itself militates against the

101

conclusion that the treatment was "derogatory" in the statutory sense …'.

And on the lyric 'string dem up one by one' Lord Justice Pill continues:

'Moreover, I am not at all sure that the meaning Mr Shipley [counsel for Confetti Records] attributes to the phrase "string dem up" is the only possible meaning. A proponent of capital punishment who says that murderers should be "strung up" would usually be taken to advocate the return of a hangman, rather than lynching...'.

He summarised as follows:

'I do not … infer any prejudice [*in the strict legal technical moral rights use we mean here*] from the invitation to "string up" "mish mish men", even if it bears the meaning that Mr Shipley attributes to it.'

On a more serious note, it seemed to matter to the Court in this case that Andrew Alcee did not personally argue for his moral rights. It can be implied that, because of the personal nature of the rights, and their attachment to the person and character of the artist, it would seem wise if going to Court to present yourself, the creator, for the Court to hear/see: i.e. if you are claiming moral rights yourself it will probably be wise to give evidence in Court: but seek legal advice.

1980s Italian films cases

Filmmakers Federico Fellini and Pietro Germi sued commercial television stations for interrupting the artistry of their films *Otto e mezzo* (8½) (1963) and *Serafino* (1969) with too many commercial breaks, invoking human rights protection as contained within the Italian Constitution. Fellini failed but Germi succeeded, but would not have done if he had given his approval (contractually presumably, with the television channels) to the 'mutilations'.[5]

There is no need to 'assert' the 'derogatory treatment' right.

Remedies

If you find you have a case for moral rights there are various legal remedies you can seek. For example, you could get an injunction to have a broadcast or publication 'pulled' if it allegedly

involves 'derogatory treatment'. Or a publisher may have to print a disclaimer or statement disassociating or distancing you, the artist, from the work as published. Damages could also be awarded, possibly with an 'aggravated' or 'exemplary' element.

Parody

UK law does not specifically say that parody is a defence: if parodying a work, you need to be rely on s.30: i.e. to be able to say that it is 'criticism or review' (or that you have not copied the work or a substantial part of the work); or make a claim for 'false attribution (s.84); or use the law of passing off (but see box, p.106).

Alan Clark v *Associated Newspapers Ltd High Court Chancery Division 21 January 1998*

This case concerned 'spoof' diary entries written for the *Evening Standard* (ES) by Peter Bradshaw (PB) parodying Alan Clark (AC).

The diary entries followed the style and layout of ES columnists so looked like 'real' columns by AC, and were written in the first person in the persona of AC. The column referred disparagingly to 'Little Major', 'little Mandelson', Heseltine, Ted Heath, and included some sexist remarks about the (unnamed) female 'New Labour Member for Watford' (Claire Ward). They were also printed under a 'mugshot' photo of AC. However, the standfirst, which appeared in a slightly larger font, was indicative of the fact that the writer was PB and not AC. The byline was also PB ('...PETER BRADSHAW imagines how the great diarist would record the event'). The actual column, with photo, is printed in Bently and Sherman's *Intellectual Property Law* (2009), at fig. 10.1.

AC made a claim against the newspaper's publisher for passing off and for false attribution of authorship invoking the copyright statutory tort of s.84 of the 1988 Act. He was successful on both heads because of the particular format adopted by the newspaper and writer.

According to a law report:

The standfirst consisted of seven lines as follows:
'IT will be a sad loss if the great diarist Alan Clark does not eventually publish a record of his campaign to retain Kensington and Chelsea for the Tories. Meantime PETER BRADSHAW, who recorded Mr Clark's capture of the nomination in January, again imagines what a new diary might contain.'

The name of Mr Bradshaw always appeared in capitals.

Following the standfirst came a photograph of the claimant and beside it in white against a black background the words (the heading): *Alan Clark's Secret Election Diary* (or after the 1997 General Election *Alan Clark's Secret Political Diaries*).

It was important to the Court that the test for parodies and spoofs – whether the general public was going to appreciate the text is a spoof and not the words of the person being parodied – is measured by how a normal member of the public reading the paper in the customary way would take it, i.e. quite possibly, in the case of the *Evening Standard*, reading in a hurry or skimming across the headlines.

> In passing off contexts, I have seen this referred to as the 'moron in a hurry' test!

There was evidence in Court both ways (of course, it was a trial after all!) but the evidence that standfirsts are commonly *not read* by the general public seemed to hold sway (i.e. evidence of people thinking this was written by AC not PB, 22 witnesses in all). If there is any evidence of people being deceived, the Court will lean in the direction of believing them, in preference to evidence from people saying they knew this was parody rather than the real AC:

> 'where it appears to the eye of the Court that there is likely to be deception, and there is evidence of rational men that they have been deceived there is little value in the evidence of witnesses who say they have not been deceived.'

The Court found persuasive the arguments that the spoof diaries were damaging to AC *as a writer*, and that their publication could potentially damage his own capacity to earn from his own publications, as opposed to protecting him as a MP. (His publications including his Conservative Party study *The Tories* and his own *Diaries* published by Weidenfeld & Nicolson).

Note: there is no need for the person alleging damage to prove actual damage caused by the false attribution, and there is no need for that person to be a professional author.

Mr Bradshaw's parodies may have been clever and subtle but they were ultimately unlawful: 'standards of reality on which to hang his fantasies'.

Other spoof columns, or parodies, which have escaped the law and fallen on the right side of the law (as cited in the Alan Clark case) are: 'The Secret Diary of John Major Aged 47¾' in *Private Eye* or 'Mrs Blair's Diary' in *The Observer* (no mugshot).

So we may love parodies and spoofs, but the law has decided to lean in the favour of the 'general public', in a policy bid to protect people from being deceived. This, too, is the essence of the law of passing off and trade marks.

Moral rights cases

Publishers beware: derogatory treatment

Fierce or unsympathetic editing or cutting or adding to an author's work could ultimately lead you to face a moral rights' claim on the grounds of 'derogatory treatment' (or even 'false attribution'). Derogatory treatment is not strictly proscribed by UK law and can cover a wide range of different acts, for example:

- Putting on a 'vulgar' dust jacket on an author's book (*Mosely* v *Stanley Paul & Co* (1917–23) Mac CC 341);[6]
- Changing names of characters and/or editing to heighten interest at end of chapters (*Humphreys* v *Thomson & Co* (1905–10) [1959] Ch 14);[7]
- Scaling down, colourising, skewing or wrongly captioning an image (see Chapter 10, Artists' Moral Rights, in Gillian Davies, *Essential Guide: Copyright Law for Artists, Designers and Photographers* [London: 2010, A&C Black].)

Publishers beware: false attribution

- Giving the impression that a second edition was written by the same author as the first was an unlawful 'false attribution' (see *Harrison* v *Harrison* below).

A recent instructive case is that of *Harrison* v *Harrison*, where the act of reprinting a second edition of a non-fiction work led the publisher to be sued, successfully, by a disgruntled first author.

The first author, X, wrote the first edition of a book, published by Y, about avoiding care home charges. The parties fell out and publisher Y commissioned Z to write a second edition. Z said he researched the material and wrote the second edition without having copied from the first edition. He did, however, acknowledge that he had 'a good look through' the first edition. Y published the second edition without running any textual comparisons, deciding it appeared to be 'very different' from the first edition. But X claimed that 35 per cent of his first edition had been taken verbatim, together with 15 per cent non-literal copying, plus obvious paraphrasing and topical re-arrangement. He sought additional damages since the copyright breach was flagrant. He also claimed he had been deliberately

excluded from profiting from the publication of the second edition by Y, who had acted in the knowledge that X's copyright had been infringed: it was argued that **by promoting the second edition by reference to the first edition, Y was implying that the two works were by the same author, which amounted to a false attribution of authorship** under the Copyright, Designs and Patents Act 1988.

The Patents Court found that there had indeed been copyright infringement (i.e. substantial copying) and false attribution; but did not agree that there had been derogatory treatment, on the basis that X seemed to be simply quibbling about Z's representation of the facts and Z's omissions. (That is, Z's representation of the facts was not as X would have stated them.) The Court also appeared to find that X had no real reputation to be damaged (he was a mere paralegal), and there was therefore no derogatory treatment (the second edition did amount to 'treatment', but that treatment was **'neither prejudicial nor capable of being so to the extent of affecting X's honour and reputation'**). X was not awarded additional damages for 'flagrancy'.

Harrison v Harrison, Patents County Court, 19 March 2010 [2010] ECDR 12; [2010] F.S.R. 25 (second edition of a book on how to avoid care home costs).

- An interesting postscript is that this would not have been derogatory treatment if the work had not been published commercially. For example, if the publication had been in-house, such as within an internal newsletter, no case could have been argued.

Interesting fact

Whilst there is no defence of parody under UK law as it stands[1] you may be able to claim your work is sufficiently original in itself that it has its own copyright, and invite the author of the first work to challenge you by proving your work is a 'substantial copy' and/or (appealing to reputation arguments) a 'derogatory treatment' or 'false attribution' under moral rights arguments.

[1] The Hargreaves Report, published on 18 May 2011, recommends UK law be amended to allow for an exception to copyright infringement for 'parody and pastiche'.

Mental gymnastics II ?!

- It is technically possible for a single work to simultaneously have its own copyright as an original creation, and yet also be an infringing work.

INFORMATION BANK

1 Copyright, Designs and Patents Act 1998, s.94.

2 Copyright, Designs and Patents Act 1998, s.87.

3 But this is in the UK only. Different countries in the world have different systems. For example, Egypt follows a more embracing author-friendly system on the French civil model, moral rights are inalienable-non-prescriptive and non-assignable. (See Makeen Makeen, SABIP conference: http://www.sabip.org.uk/home/events/events-moralrights.htm.)

4 Article by Paul Taylor for *The Independent* 18 March 1994: search for 'samuel beckett' at http://www.independent.co.uk/

I am reproducing Paul's first paragraph in full here since he puts it so well: 'Samuel Beckett once tried to put a stop to the first New York production of a theatre piece he had written, on the grounds that a stage direction had been violated. Given that the 35-second *Breath* (1969) consists of nothing but a stage direction, this intervention is not as pedantic as it sounds. Certainly, the producers of the Broadway *O (Calcutta)*, [sic] to which the sketch made a contribution, can't have been unaware that there's a world of difference between "Faint light on stage littered with miscellaneous rubbish. Hold light about five seconds", and the same orders with the phrase "including naked people" inserted after the word "rubbish".' (Stage directions are also protected by copyright as 'dramatic works').

5 This is French law not UK. Source: *Oxford Journal of Legal Studies* 18:1 pages 61–73, 'Art and Money and Constitutional Rights in the Private Sphere', Christoph Beat Graber and Gunther Teubner.

6 The facts of this case are hilarious, if sparse on the ground (the law report is a very cute, two-mini-pages long; compare this with 21st-centurty 'blockbuster' law reports like *Da Vinci Code*, which in its High Court ruling manifestation alone (part 1 of 3 parts) stretches to some 71 pages!). The book was a satire called *The Much Chosen Race*, and was 'along the lines of *The Unspeakable Scot*'. The jacket, 'consisted of a pictorial representation of an old Jewish pedlar with four hats on his head and with a number of small pigs in a tray!' Mr Justice Sargent ruled for the High Court that this clearly conveyed the impression that the contents were vulgar and offensive, which constituted a libel on the author.

7 This case involves a romantic work of fiction by an author whose pen name was 'Rita'. Rita wrote a romantic novel, which the case note tells us was variously published in whole or serialised form by several publishers, as: *A Pair of Sinners, The Sinner, The Mills of God, The Grinding Mills of God* (!), *Nellie O'Neil* and, finally, by the *Red Letter* periodical (the defendant publication), *Katie Thorne: The Romance of a Hospital Nurse*. The *Red Letter* edited it heavily, cutting prose and descriptive passages extensively; changing names ('because it was essential to have names which could be easily pronounced and remembered by humble readers'); and introducing 'curtains' to whet the audience's appetite for future parts of the serialisation.

The author's action for damage to reputation was partially successful: the jury found the publisher guilty of damaging the author's reputation, but the judge ruled that there had been no passing off such as to damage her reputation and refused to award an injunction to prevent the publication continuing to be circulated.

15

Dates, Deadlines and Money

The value of copyright

Copyright strengthens the economy and, if handled properly, can make an individual editor or writer a bit wealthier. According to the Publishers Association:

- 8 per cent of all economic activity in the UK is generated by industries that depend on the copyright framework for their continued success. Together they create millions of jobs. 'The UK owes its position as the largest exporting publishing industry in the world to our strong copyright laws.'
- In 2009, UK publishers sold 763 million books around the world.
- Three of the top four highest-grossing movie franchises are based on British books: James Bond, Harry Potter and *The Lord of the Rings*. Between them, they had grossed over US$13 billion by the end of 2009.

The export value of books to the British economy in 2009 was £1.2 billion.

But what about copyright's value to the individual writer or editor? Table 15.1 charts some routes to doubling up on earnings if you are published.

Table 15.1: Royalties from collecting societies

Month	Apply by	To	for	relative to	£
June	30 June every year	PLR (Public Lending Right Scheme)	Authors, illustrators, contributors *named on the title page* of books.	Books: anyone named on the title page is entitled to a per cent share of a pool of government monies held for public library lending rights.	Payments made each February: minimum payment £1 – maximum £6,600[1]
September	30 September every year	DACS	A share of 'payback' royalties collected for artists and photographers.	Illustration, photography	Minimum payment of £25; highest individual payment around £5,000–6,000
To be confirmed!	A date which was formerly 31 March 2011, but which is now uncertain following rejection of the Google Settlement. Likely to be not sooner than 22 February 2012.	Google	One-off payment for the digitisation of your work (content digitised before May 2009). As long as you have not yet 'opted out' of the Google Settlement, you can register as a rights-holder (by 31 March 2011) and claim a retrospective digitising payment.	Works published in the US, UK, Canada or Australia before January 2009; applies to 'rightsholders', including authors; inheritors of an author's estate; publishers; and (if their contribution means they are effectively co-authors) illustrators, translators and editors.	One-off payment in the region of £36–180 (books and anthologies). £9–45 ('entire inserts') £3–15** ('partial inserts')

Table 15.1: Royalties from collecting societies, continued

Month	Apply by	To	for	relative to	£
January 2013	1 January 2013		US copyright owners should be aware that copyright contracts may be up for renegotiation on 1 January 2013. See below:		
Any time	Any time in the year; claims can be made retrospectively for three years only: i.e. count back from today's date three years and you can claim; if older you cannot.	ALCS (Authors' Licensing and Collecting Society) money collected for photocopying licences	If you have written a book, television script or article in a magazine or journal. NB can apply to editors who do a bit of writing e.g. news pages in an academic journal where experts supply features.	Academic writers, fiction, non-fiction, translators, adaptors, scriptwriters, magazine and journal article writers, editors and children's writers.	Distributions made by ALCS twice a year, in February and August.

INFORMATION BANK

Google 'inserts' are defined on the Google Settlement website. This example helps to explain them: 'if you own rights in a poem that is contained in a Book for which you also hold a US copyright interest, then your poem, as it appears in your Book, is not an Insert; however, it would be an Insert if the poem is contained in a Book for which someone else holds the US copyright interest.'

Settlement administration website for the Google Book Search Copyright Class Action Settlement: http://www.googlebook settlement. com. Visit for news and to make a claim or opt out.

The Society of Authors is keeping its website up-to-date on behalf of UK writers:

www.societyofauthors.org/soa-news/ google-settlement.

To apply for PLR you need to complete a form: http://www.plr.uk.com/registrationservice/ formsLeaflets.htm.

ALCS http://www.alcs.co.uk/

US: 'The clock is ticking. On 1 January 2013, provided timely Termination Notices were sent (and recorded with the Copyright Office) grants made on 1 January 1978 will terminate.' See http://www.copylaw.org/p/termination-of-book-music-publishing_17.html.

Publishers Association: *The value of copyright*, 1 August 2010 http://www.publisherassociation. org.uk.

Table 15.2: Copyright term

Types of works	Duration of copyright ('term')	Notes (and, where applicable, detail of section from 1988 Act)	Grey areas	Applicable to music?
Literary works, known author	lifetime of the author (PMA) plus 70 years after death	Includes translations applies to directors, dialogue authors, screenplay authors, computer programmers		
Literary works, anonymous/ corporate works	70 years from year of publication			
Literary works created before 1 August 1989	lifetime of the author plus 50 years after death			
Literary works, unpublished, created before 1 August 1989 and held by an archive or similar which is open to public inspection	lifetime of the author plus 50 years after death or 1 January 2040, whichever is soonest, or PMA plus 70 years if longer			
	'Provided that more than 50 years have elapsed from the end of the calendar year in which the author died, and more than 100 years have elapsed after the making of the work, then the work may be reproduced for the purposes of research or private study, or with a view to publication': 1956 Act s.7; 1988 Act Schedule 1, paragraph 16. Source Copinger & Skone James on Copyright 9-112			

Table 15.2: Copyright term, continued

Types of works	Duration of copyright ('term')	Notes (and, where applicable, detail of section from 1988 Act)	Grey areas	Applicable to music?
Literary works, unpublished, created before 1 August 1989 and not in the public domain	works unpublished at the author's death, and still unpublished as of 1 August 1989, are protected for 50 years counting from 1 January 1990 (i.e. will be in the public domain from 31 December 2039)			
Literary works, unpublished, works created after 1 August 1989	the librarian or archivist can make a copy of the whole or part for the purposes of research or private study with certain other conditions: 1988 Act, s.43 Schedule 1, paragraph 16. Source *Copinger & Skone James on Copyright 9-113*			
Literary works created between 1925 and 1945	lifetime of the author plus 50 years after death plus an additional 20 years in some exceptional 'revived copyright' circumstances (see p.115).			
Musical works	composer's life plus 70 years	scores		✓
Artistic works	lifetime of the creator plus 70 years after death	Paintings, drawings, photographs, prints, sculpture, collage, architecture, crafts		
Computer-generated works	50 years from the end of the year first created	including literary, dramatic, musical works		✓

Types of works	Duration of copyright ('term')	Notes (and, where applicable, detail of section from 1988 Act)	Grey areas	Applicable to music?
Databases	Lifetime of the author plus 70 years or 70 years from end of year of first publication or if a sui generis database, 15 years, renewable when investing effort in updating by a further 15 years, for databases made on or after 1 January 1983	bibliographies, directories, lists, price lists, tables		
Sound recordings	50 years from first publication	s.13A		✓
Films/moving images	70 years from the death of whoever is the last to survive from: the principal director; author of dialogue; author of screenplay; composer of music specially created for and used in the film	s.13B		✓
Broadcasts*	50 years from when first broadcast	transmissions via wireless telegraphy through the air (not via cable or wireless) including satellite (see Cornish, Copyright in a Week [2002] p.58)	Does the creation of a hypertext link on a website amount to a broadcast?	
Published editions*	25 years from first publication	typography and layout e.g. magazines and newspapers, usually owned by publishers		

Table 15.2: Copyright term, continued

Types of works	Duration of copyright ('term')	Notes (and, where applicable, detail of section from 1988 Act)	Grey areas	Applicable to music?
Crown copyright	50 years from end of year first published; unpublished: 125 years from date first created			
Parliamentary copyright	50 years from end of year first created	House of Commons, House of Lords		
Joint works	70 years PMA taking date of death of the last author to die (s.12(8))			
Works of unknown authorship	70 years from end of year of creation or, if during that period the work is made available to the public, from the year it was made available (s.12(3)) ('made available' will be most commonly by publishing, putting on internet, performing).			
Anonymous/ pseudonymous works	see s.57			
Works published posthumously	70 years from the date of publication			

Table 15.2: Copyright term

After these set periods of time copyright works fall into the 'public domain' and can – in theory – be used or copied without permission. Take care, especially with authors who died between 1925–45 (see Chapter 8: Arthur Conan Doyle: Case Study on Revived Copyright). Also look out for any works which were the subject of UK copyright contracts signed before 1 June 1957, and for US contracts signed on or after 1 January 1978 (see p.117).

Some jurisdictions, e.g. Germany and Sweden, are campaigning to expand this category of rights to cover a new typographical-type right for digitised works.

Interesting fact	Term: always runs out on 31 December no matter what year so the date of entry into the public domain is 1 January the following year. e.g. A dies 10 January 1990. Copyright expires on 31 December 2060, public domain from 1 January 2061. B dies on 30 December 1990, 11 plus months later. But copyright expires at the same time: on 31 December 2060, public domain from 1 January 2061.

Source: this table was taken from Pedley, *Copyright Compliance* (2008), but then added to by checking primary sources and by feeding in data gathered for research used elsewhere in the book including independent reading of case law. It therefore has it's own copyright! Table 15.3 is likewise ultimately derived from Garnett *et al.*, *Copinger & Skone James on Copyright* (2010).

Table 15.3: Terms of moral rights (not assignable but can be waived)

Right	Description	Term/duration of copyright protection	Who can invoke it?	Exceptions for deceased authors	Part of work applicable?
paternity right	right to be identified as author/director	subsists as long as copyright subsists	exclusive to author	Does not apply if the author died before 1 Aug 1989	whole work or substantial part of work
integrity right	right to not have work subjected to 'derogatory treatment'	subsists as long as copyright subsists	exclusive to author	Does not apply if the author died before 1 Aug 1989	whole work only
false attribution	right to not have work falsely attributed to you	applies for only 20 years after author's death (s. 86(2)), as long as it qualifies as a 'work' under s.84(1)	can be enjoyed by any person, author or not (e.g. the author's estate)		whole work only
photo privacy	right to privacy in photos commissioned for private and domestic purposes	subsists as long as copyright subsists	can be enjoyed by any person, author or not (e.g. the author's estate)	Does not apply to photos taken or films made before 1 Aug 1989	whole work or substantial part of work

1 June 1957: 'contract bumping'	For works which were the subject of copyright contracts signed before 1 June 1957, an old copyright law (now repealed) still applies: referred to as the 'reversionary right' the law allowed authors' families, or estates in some cases, to recapture copyrights signed away by authors after a period of 25 years after the author's death, even although the author had signed the copyright away during her lifetime. So, no assignment or grant of any copyright licence made between 16 December 1911 and 1 June 1957 in the UK is effective (except if made by a Will) if it purports to grant copyright for more than the PMA plus 25 years period. The assignment or grant will be interpreted as if it is for 25 years only regardless. *Unless* another new assignment or grant was made after 1 June 1957.

A similar law still applies in the US and is causing some publishers giant headaches because on 1 January 2013 a 35-year cap (or 'copyright termination time bomb') arises: s.203 of the 1978 US Copyright Act[2] applies to grants of copyrights *signed* on or after 1 January 1978 by the author – *not* grants signed by an author's heirs. For the US position, which is generally that during 2013 authors' families may ask for copyrights back, see the articles below[3].

ALCS/DACS/Google/PLR

Google and Book Rights Registry

The Google Settlement is all about rights management. If approved, a Rights Registry will be founded as part of the settlement. The proposal is for the establishment of the Registry to be funded by Google as part of the settlement, but for it to be an independent, not-for-profit organisation that collects and disburses revenue from users of content (in the first case, only Google) to authors, publishers and other rightsholders. The Registry will, therefore, need to have access to rights information for all books (and parts of books) covered by the agreement, and also their authors and publishers. Publishers wishing to claim works via the Book Rights Registry (for example to receive royalty payments or to opt-out or set licensing terms) should do so via the website www.googlebooksettlement.com.

Google update Spring 2011

In March 2011 the US District Court for the Southern District of New York (Judge Chin) rejected the Google Settlement, refusing to rubberstamp an arrangement that would allow Google to use authors' works (and 'orphan works') without specific consent. The judge hinted that he would look more favourably at an agreement whereby authors and rightsholders had to specifically opt-in to the scheme (as opposed to the default 'your-works-will-be-used-by-Google-unless-you-object' opt-out, which was rejected in March 2011). However, it has to be said that even an opt-in solution would not address the vexed issue of 'orphans'. One way or other as we go to print, Google does not have the blessing it had hoped to have from creators and publishers by now to digitise works on any carte blanche/wholesale basis. Instead Google must continue to seek copyright consents like the rest of us, painfully, on an individual basis, which is no good to Google, and probably no good in the long-run to authors and publishers wishing to sell rights, but at least throws back some appearance of control into the hands of authors, or more properly, publishers. This is an odd game, and is not over yet.

INFORMATION BANK

[1] PLR: DCMS provided £7.22 million to PLR in 2011–12. The figure will drop to £6.96 million by 2014–15. PLR applies to public library lending only, not to university libraries etc. Ownership of copyright has no bearing on PLR (usually the publisher will have copyright but the author or editor gets PLR if she registers whether she retains any part of her copyright or not. Most authors receive between £1 and £100 a year. Translators get a 30 per cent fixed share (of the text share i.e. the figure the author would get if named alone); editors/compilers get 20 per cent of the 'text share' if they have written 10 per cent of the book or have written ten pages on top of their editorial contribution, but this can vary. Registration must take place during the lifetime of the author but a registered author can also have new books registered after their death if the book is published within a year before their death or ten years after death. New versions of already published titles can be registered posthumously too. www.plr.uk.com. There are currently (winter 2010) moves afoot to reallocate PLR's role to another body.

[2] US Copyright Act of 1978, s.203 can be found here: http://www.copyright.gov/title17/92chap2.html

[3] Jassin, 'Termination of Book & Music Publishing Copyright Contracts', www.copylaw.org/p/termination-of-book-music-publishing_17.html and Copyright Asteroid Hurtling Toward Earth, Impact Due 2013, http://ereads.com/2010/09/copyright-asteroid-hurtling-toward-earth-impact-due-2013.html.

16

Other Very Interesting Bits and Bobs

Editors and tables, indexes and anthologies

Tables, indexes and anthologies are protected by UK copyright law as 'compilations', and may also be additionally protected as 'databases'. This can apply equally to works as far apart as Norton's English Literature anthologies; statistical or scientific data; listings; collections of short stories; historical works, poetry or quotations.

Again, the guiding principle is whether, in the editorial selection process, the author or editor has deployed levels of skill and devoted effort and time into putting together something that would enable others to dispense with putting in the same work if they repeat or copy the compilation or elements of the compilation, and if they, the 'copier' stand to gain commercially from so doing. That is the overarching principle, but the devil is in the detail and here we have an awful lot of detail and many conflicting cases. If interested in this area the best thing to do is consult the leading law textbook on the subject *Copinger & Skone James on Copyright* (C&SJ), at pp.398–404. The following will give you a glimpse of some of the cases discussed by C&SJ, and some of the different (and conflicting) rules that appear to emerge from – incidentally very old – case law (many of the leading cases in this area date from the 19th century):

- if you copy a compilation, but go back to the original sources to check the information, you might still be infringing (a recent case on this involved a legal directory: *Waterlow Publishers Ltd* v *Rose* [1995] FSR 207);
- even if the information in the first work is not available elsewhere, copying still may not be allowed (there are cases concerning football fixtures and television schedules);
- it may be permissible to use another person's work to find sources you wouldn't have thought of otherwise in order to come up with a work on a similar subject (there is a case here

going back to 1869 about a book on the origin of the English nation);

- it may be permissible to use another's work as a reference source to cross-check your information, or to see if you have forgotten anything;
- the editor's skill in selecting a quotation may be protected by copyright, according to C&SJ, so presumably this could be stretched to apply to the compilation of things including, say, vintage knitting patterns;
- the addition of more material on top of the material copied from the first work may not be decisive ether way: see the *Ravenscroft* case discussed in Chapter 6, where only 4 per cent of the work was found to have been copied, but it was still infringing for its language and non-language copying;
- if you re-arrange or scramble the materials you might still be infringing if there was originality in the way the first author/editor had chosen to arrange her materials.

Joint works

We are talking here about collaborative works where the contribution of each person is not distinct in the work created (if you can separate out the contributions the work is 'co-authored' not 'joint': a classic example being music which can be split into the literary copyright in the lyrics, mechanical rights for the sound recording, composer's rights, performance rights etc.).[1] There must have been a process of collaboration and a joint goal. Copyright law treats 'joint works' as a special case: films are usually the joint works of the producer and principal director if they are not the same person. Stuart Weinstein gives the example of a website as a joint work:

> 'Joint ownership might arise, for example, if a person was commissioned to create a website together with one of the company's employees. It is likely that both the person being commissioned, and the company would be joint first owners of copyright in the website. If someone wanted to copy or use a work of joint ownership in some way, all of the owners would have to agree to such a request, otherwise an infringement of copyright could still occur'.[2]

In practice, however, with websites, the operator would want

*to get separate copyright assignments or licences from **all** of its contributors: software, audio, copy, photographs, graphics, etc.*

There are grey areas, of course:

- what about a children's story book written by A and illustrated by B? There are probably two distinct works and two separate copyrights there
- or the two script-writing brothers in the children's television cartoon case seen in Chapter 14: *Christoffer* v *Poseidon Film Distributors*)? (It is not actually clear from the case transcript how the two worked.)
- if you remember Spandau Ballet's 'Gold', the Court there held that the saxophone solo in the middle might be a distinct work, giving rise to a separate copyright and not a joint copyright.[3] Joint copyright is actually pretty tricky intellectually.

Some important practical advice from media lawyer Ian Bloom needs to be heeded here:

'Joint writers must, must, must, set out in a written document ("written" for evidential purposes) the percentages each of them holds in the copyright of the work. It doesn't have to be 50:50 or 25:25:25:25 – it can be whatever they decide. But failure to record an agreement can be disastrous. It doesn't have to be a formal document written by lawyers – a clear short letter from A to B and signed and dated by them both making express reference to the work is sufficient.'

Business correspondence (letters and emails)

There is a High Court decision to the effect that a business letter can be protected by copyright (as well as breach of confidence), as the product of sufficient skill and labour to be copyright-protected as an 'original literary work' and its circulation (and copying) may not be afforded a defence of criticism or review. The case is called *Cembrit Blunn* v *Apex Roofing* [2007] EWHC 111 and takes us into the unlikely world of the construction industry.

A roofing contractor fell out with a tile manufacturer on the basis that the tiles were allegedly defective. An exchange of letters and emails followed, with the tile supplier offering to remedy any defects and the contractor (Apex) refusing these offers. Ultimately Apex started a smear campaign writing press

releases and offering bad press articles to trade magazines, including of photos of the tiles (curled up and 'defective'). At the centre of the copyright issue is an internal letter from a senior businessman at the head of the tile manufacturing company's headquarters, based in Denmark (Dansk), to associates in the UK (the UK distributor of the Danish company's tiles, Cembrit), i.e. a letter between two parties on the claimants' side.

The letter related to ongoing negotiations, recommended continued offers to settle the matter and to avoid going to court – especially since the case might be weak (this paraphrases the words of Dansk Exec V-P: his letter ends '... For the sake of good order, I also wish to emphasise that to the extent possible we should avoid being involved in court cases – in particular if we have a bad case.'). Cembrit's side complained that there had been a breach of copyright in the circulation and copying of this letter. The court agreed that that was so, and that there was no available defence of fair dealing for criticism or review. I am unable to understand the logic of the copyright decision here because it is not clear from the transcript of the judgment which expression of the copyright work was supposed to be the infringing one: i.e. the judgment does not say that it was the published articles or the press release that was offending the law of copyright, it just speaks of the 'circulation' of copies of the letter. I am not convinced that this correctly applies the 1988 Act. Are we not talking about the information which the letter contained rather than the form of expression of that information?

That business letters can be protected by copyright has been described as 'surprising' by two Court of Appeal Judges when called upon to consider the matter in *Musical Fidelity Ltd* v *Vickers* [2002] EWCA Civ 1989, where the Court was looking at solicitors' letters. But the Court referred to the source of the law as an older case of *British Oxygen Co Ltd* v *Liquid Air Ltd* [1925] 1 Ch D 383, and did not take the opportunity to change the law, so it stands: *Cembrit* and *British Oxygen* do offer at least the opportunity of arguments that letters (and perhaps emails) can be protected by copyright.

Editors/Secondary infringement

This issue was not discussed in court, but what if you were the editor of *Construction News* or *Roofing Magazine*, in receipt of Apex's information? Would you (or your company) be liable under

the law of copyright for being in possession during the course of business of copyright-infringing material? The answer is 'yes – possibly'.

The *de minimis* rule and book titles

There is also a *de minimis* rule in copyright whereby no copyright may attach to a single word or words. But this rule is arguably historic and has been eroded in recent times.

Under the old statute (1956 Act) the courts decided that the corporate name 'Exxon' could not be an original copyright work because of the *de minimis* rule. Trade marks will protect names such as this, however, and perhaps also *noms de plume*, and the common law of 'passing off' might help also (you can also assert moral rights for a *nom de plume*).[4]

However, in a more recent legal skirmish relating to a pioneer 'internet-age' copyright case, a lower level court did suggest that (literary) copyright could vest in newspaper headlines that had been created into deep hyperlinks, so that the creation of a hypertext link to a competitor paper was potentially infringing.[5] There, *The Shetland Times*'s headlines (e.g. 'Bid to save centre after council funding "cock up" ') were copied verbatim into the website of *The Shetland News* as hyperlinks on the latter's site, which linked directly to the *Times*' stories. (Note, however, that this did not go to a full trial so the legal issues were not fully argued).

I personally do not like the *de minimis* rule: surely some of the greatest 'literary works' of all time have been single or paired words? I am unable to express how impressed I am at the skills level of sub-editors on national newspapers who, under extreme time pressure, come up with short headlines to fit a tight space. But the rule might apply, so it is worth bearing in mind. And it is also perfectly understandable that some people would prefer not to grant monopoly rights to the author of the name *The Wombles*, for example.

In terms of trade marks, the band Wet Wet Wet sued Mainstream Publishing for using 'Wet Wet Wet' in the title of a book about the band, appealing to trade marks law (not copyright). Mainsteam successfully defended the action under s.11(2)(b) of the Trade Marks Act 1994: the fact that the title of its book (*Sweet Little Mystery – Wet Wet Wet – The Inside Story*) as it appeared on the dust cover and spine of its book used the name

which had been registered as a trade mark did not make that use infringing: it was obvious that the publisher needed to use the name to describe the contents of the book. That decision (of the Scottish Court of Session, Outer House) was however criticised by the High Court in London in 1996 in *British Sugar* v *Robertson* [1997] ETMR 118.

Book and article titles

Anyone can re-use a title if it is purely descriptive; but not if it is 'fancy' and essentially distinctive; a grey area looms over titles which are both descriptive and arguably distinctive. (There might also be legal issues to consider such as 'passing off' if the same title is used for books which have the same subject matter, but a discussion of that tort is outside the scope of this book). As examples I suggest the following:

- **'Purely descriptive'** and therefore fair game for 'copying' would be a title such as *Stories for Children*, *Natural First Aid*, *Copyright Law* or even *Copyright Law for Writers and Journalists* or *Stories for Seven-Year-Olds*. The Society of Authors also offers the following example: *The Life of St Paul*. What about *The Book of Love*?
- **'Fancy and essentially distinctive'**, and therefore more likely to give rise to a copyright problem if re-used without permission, might be titles such as *'Tis*; *Slow Loris*; *Feminine Gospels*; *The Town That Forgot How To Breathe*. The Society of Authors offers the following examples: *Moonraker*; *The Subtle Knife*.
- **In-between** (descriptive with an element of fancy) and therefore on not such firm ground might be titles including *Last Man Standing*, *The Green Witch*; *Worth Dying For*; *The Birth of Venus*; *Abigail's Party*; *The Eye of the Storm* (Shay mentions that this was used by Nobel prize-winning novelist Patrick White and also by thriller writer Jack Higgins, but it has also been used several times in other fiction and non-fiction works; Shay, *Copyright and Law for Writers* [2008]). The Society of Authors offers the following examples: *Splendid Misery*; *Where There's a Will There's a Way*; *The Younger Generation*; *Irish and Proud of It*; *The New Car*.

Some titles may also attract trademark protection (see *Wet Wet Wet* above). And passing off may arise if the original author thinks the public is being led to believe the first author is involved with,

or in any way endorsing, the title (see Alan Clark Diaries case in Chapter 14).

Characters

Because, as we have seen in Chapter 3, UK copyright does not protect 'ideas' as such, but the expression of those ideas, things like characters and plotlines or TV show formats can slip through the net and not be copyright-protected. You may have read reports about Ricky Gervais being the subject of a copyright complaint because author John Savage says Gervais' best-selling book *Flanimals* is based on his own original work *Captain Pottie's Wildlife Encyclopedia*. Unfortunately for Savage the onus is on him to prove that a) his work was created first, and b) that Gervais' work has copied the whole or a substantial part of *Captain Pottie's Wildlife Encyclopedia*. The courts would not be impressed if Savage can only show how an idea could have been borrowed/adapted.

Indeed, as we have seen, even two very similar versions of the same thing can have individual copyrights: obviously this could apply to two (or more) adaptations of the same story. A very good article on the copyright protection, or lack of it, for characters under copyright law can be found in *The Author* by Nicola Solomon.[6]

And also note US law differs in its protection of characters: see Chapter 8 and the example of Arthur Conan Doyle.

INFORMATION BANK

[1] *Green* v *Broadcasting Corp of New Zealand* [1989] RPC 700, JC.

[2] Wild *et al.*, *Electronic and Mobile Commerce Law* (2011). Websites as a whole, and elements of sites, might also be protected as preparatory materials for computer programs under paragraph (c) of s.1(1) of the 1988 Act. And websites can also enjoy protection as *sui generis* databases under European Directive 96/9/EC, as applied in the UK by the Copyright and Rights in Databases (SI 1997 No 3032). See further L Zemer, *Contribution and collaboration in joint authorship: too many misconceptions* JIPL&R 2006 1(4)283.

[3] *Hadley* v *Kemp* [1999] EMLR 589

[4] Society of Authors, *Guide to the Protection of Titles, Members Only*. and *Exxon Corporation* v *Exxon Insurance Consultants International Ltd* [1981] 3 All ER 241; see further David Bainbridge *Intellectual Property* (Longman, 5th edition, 2002) pages 46–7.

[5] *Shetland Times Ltd* v *Wills* 1997 SC 316

[6] 'What a Character!', *The Author*, Spring 2001.

17

Plagiarism

By Ian Bloom, Ross & Craig Solicitors

Plagiarism is separate from copyright infringement and is actionable as a distinct legal cause of action. It is a creature of the common law (i.e. there is no specific statute that prohibits it) and claims for plagiarism are unusual. But a claim can be made, and often to good effect, either separately or in addition to an action for copyright infringement. If we are being cynical about it, then the difference between plagiarism and research is this: plagiarism involves copying someone else's work; research involves reading several different sources and copying bits out of each of them. Plagiarism is the antithesis of originality. It is both hated and feared by creative talent.

Some of you may recall that 40 years ago George Harrison, having escaped the giant shadows cast by Lennon and McCartney, released a triple album called *All Things Must Pass*. One of the standout songs on that album was *My Sweet Lord*. When the copyrightholders of the Chiffons' *He's So Fine* heard the song, they thought, 'it's very, very similar'. Five years later, when the case was finally heard in the High Court, the judge agreed. No criticism was made of George Harrison in the sense that no one said he had deliberately plagiarised the melody line of *He's So Fine*, but the judge found that the similarity was too strong. Unconscious plagiarism it may have been, but plagiarism it was nonetheless.

Apparently when Paul McCartney woke up one day in the Sixties, having dreamed the melody of *Yesterday*, he was convinced he had heard the song elsewhere and it was not original. Since no one could identify his tune, he adopted it and the song became one of The Beatles' biggest hits. The point is that it is impossible for musicians or artists to know if they are unconsciously copying. It is always easier to know if they are consciously copying, but the fear of unconscious copying is ever-present.

There have been several well-publicised cases of authors copying the works of other authors. Is this ripping off? Is it

plagiarism? Is it research? The whole area is down to interpretation and, as judges will always say, each case will turn on its facts. The questions are those of extent and degree. Intent is not really the issue. Intent has a criminal law connotation. 'Did someone mean to hurt someone else?', is an important issue if assessing or deciding criminal liability. It has no role to play in the civil tort of plagiarism. How can any of you reading this book and thinking about your first novel, or maybe your second or third, be sure that your deathless prose is original and not copied? Well, in fact, you can't. If you do start writing about a 13-year-old schoolboy with magical powers who goes to a school beginning with H, you might just find endless derision when you hand your masterpiece to a friend, an agent, or a publisher to be read. But if you find phrases and sentences at the back of your mind and you wonder where they come from and whether are they original, you may not find out until it's too late and the claim form arrives. In fact, single phrases and single words will not normally cause you a problem (for plagiarism). Whole passages will.

The consequences for plagiarism can be severe because damages are normally payable to the copyright holder who is aggrieved and whose work has, to some extent, been stolen. These damages can be significant, but worse still (as for libel actions) will be the legal costs involved. As has been examined in Chapter 5, a few years ago, Dan Brown was 'accused' of copying chunks of The Da Vinci Code from an earlier work, ironically published by the same publishers and itself a bestseller. Although Dan Brown admitted reading the earlier book, and although he agreed that he (and, indeed, his research-assistant wife) had followed certain themes, it may be said, perhaps cynically, that he had done so much research that he had successfully managed to weld his sources into a coherent narrative, whereby it was impossible to pick out paragraphs he had 'copied' from his sources and thus be damned for direct plagiarism. He was successful.

And perhaps that is as it should be. Plagiarism cases are rare. They are rare partly because of the cost and partly because authors and journalists do not willingly copy other writers' work. I know that in one sense, if you read the London Evening Standard, you might sometimes think that you are reading a later version of the Daily Mail, and if you read the Daily Mail the morning after you have read the Evening Standard, you might think you are reading an early morning version of the Evening Standard the next day

because the stories are summarised, sometimes shamelessly, but in that case it's all one publisher, Associated Newspapers. And, bizarre as the practices of newspaper proprietors might be, they rarely sue themselves.

INFORMATION BANK

See also 'Plagiarism' in *The Author* (Autumn 2005).

18

Going to Law

By Ian Bloom, Ross & Craig Solicitors

Like many legal topics, copyright is not, itself, hermetically sealed into a box of its own. Other legal concepts and topics are relevant, such as libel, touched on in Chapter 12; or plagiarism, discussed in Chapter 17.

This chapter should, in reality, be called '**Not** Going to Law'. The best advice I can give, as someone who has written, edited and published, but for most of his working life been a practising lawyer, may be heresy in some legal circles, but I'll offer it anyway: avoid the law at all costs if you possibly can.

In many chapters in this book, you will find some variant of the phrase: 'The courts may decide...'. This provisional and conditional language does not mean that we, the writers, are uncertain: it means that the law is uncertain in that, until a specific set of facts is presented to a judge, there is often no easy way of deciding what the 'right' answer is to a particular question. You can, for sure, read *Copinger & Skone James on Copyright*. But with great respect to the wise editors of that impressive doorstop of a book, it is hard going. And it is very long. And the current edition also costs £415. You can consult any number of other legal textbooks on intellectual property or media law generally. They will not necessarily give you the answer relevant to your situation.

English law is based on statute and on precedent. The governing statute for copyright is, of course, the Copyright, Designs and Patents Act 1988. There have been subsequent statutory instruments and regulations made which affect or amend certain provisions in that Act. There have been dozens of cases on copyright over the last 300 years. But, unless you spend an extraordinary amount of time researching them, you are unlikely to find a definitive answer to your problem. Even if you think you have found it, once you are in a legal dispute, you will not necessarily be able to persuade the other side that you are right. Especially if they have deeper pockets than you and are willing

to test your bank balance and nerve by continuing to challenge the arguments you put forward. The late Robert Maxwell did not always have right on his side when he sued, or threatened to sue. But he could, and often did, cow the less well-off and powerful into submission with the tactical use of the law and lawyers.

You can always take legal advice, but the downside is that copyright expertise is not cheap and you are unlikely – ever – to obtain legal aid for a copyright dispute. Nor will you obtain legal aid to bring defamation proceedings or to defend them, since legal aid is simply not available for this area of law. And the odds are that the subject matter of your copyright dispute has an intrinsic value that is disproportionately small compared with the costs that might be involved if you are unfortunate enough to have to litigate that dispute. Like most litigation, copyright litigation is best reserved to those who can afford to lose, particularly when the costs regime in this country means that the losing party normally has to pay around 70–75 per cent of the winning party's costs.

The one ray of light in this otherwise dismal landscape, in which a lawyer who you would normally expect to encourage you to litigate, is uttering this severe health warning against doing so, is the availability of conditional fee agreements (CFAs). They were originally introduced into English law about 20 years ago to help personal injury claimants. In 1998, they were extended to defamation and most other civil claims. In fact, they were made even more user-friendly by allowing claimants to pay success fees to their lawyers and also obtain after-the-event insurance, which covers the claimant's liability to pay his opponent's costs if he lost.

This has certainly given libel claimants operating under a CFA, a significant advantage in dealing with newspapers, since the newspapers can no longer rely on the cost and uncertainty of litigation forcing many claimants with decent enough claims to drop them.[1] And there is no doubt that, if you can find a solicitor and sometimes a barrister who will run your dispute, be it a copyright problem, a libel case or any other civil litigation, on a CFA, you will have a valuable tactical advantage over your opponent.

The best advice, however, for those of you unlucky enough to become embroiled in a dispute, is still to compromise, mediate, arbitrate or use a third party to intervene to avoid lawyers, if you

possibly can.

And if that doesn't work, you can always try direct action. I am emphatically not recommending defamatory postings on the internet, far less physical intimidation. But a 'name-and-shame' blog; an online diary or a Twitter campaign could prove surprisingly effective in persuading your corporate opponent to reconsider its position. It will be much cheaper. And you never know: an organisation that had previously said 'no' to your letters or ignored them altogether, might just find more merit in your claim than was initially apparent when you gather an army of supporters. The trick is to focus on merits and not abuse; reasoned argument and not name-calling, mockery and wit and not libellous untruths. After all, all's fair....

Interesting fact

Solicitors in copyright cases are commonly to be found with highlighter pens in their hands, comparing texts where there has been alleged unlawful copying, because in analysing evidence the courts will examine blocks of text, or words or phrases. These might be divided into two categories by lawyers: 'true copying' (text lifted directly) or 'altered copying' (text that looks like it has derived from another work: and an argument needs to follow to decide if this is lawful copying or not).

INFORMATION BANK

[1] A campaign to reform the current libel law has attracted widespread support and is likely to lead shortly to legislation that will limit the use of CFAs by claimants

19

Maximising Earnings: Tax, VAT and royalties

In association with Stephen Simou of Citroen Wells Chartered Accountants

This is a book about copyright and not tax so I am only jotting down a few 'triggers' which may be useful to have in mind as you go about your business as a writer or editor: all these notes are aimed at the self-employed.

Income tax

Registration for self-assessment is mandatory and must be done by 5 October after the end of the tax year in which you start out as a self-employed worker, or else penalties apply. Those who have fluctuating levels of income and become higher rate tax payers in one particular tax year may find it advantageous to use *Helpsheet 234*, 'Averaging for creators of literary or artistic works' (www.hmrc.gov.uk/helpsheets/hs234.pdf), if writing and editorial work is your only source of income. Higher rates of tax currently become payable on taxable income exceeding £35,000 and the averaging of profits from one tax year to the next can result in greater use of the lower rate tax bands and hence an overall tax saving over the two years. You will pay income tax at a rate of 20 per cent on profits after the first £7,475. 'Capital allowances' are available on expenditure on new computers, phones, printers, desks etc.: there is a way to spread these out advantageously so ask an accountant or adviser for help. Grants and prizes are probably not taxable as income, but it is safest to declare them by way of a note to the HM Revenue & Customs (HMRC) anyway.

If you need to sub-contact work sometimes, say to a proof reader, web designer or photographer, ask the person working for you to fill in form P38 if they are a student (and also get them to assign copyright). All forms should be filled in up-front, of course. PLR receipts to UK residents are made without deduction of tax and should be declared as part of your income.

You will also pay Class 4 National Insurance at 9 per cent on your profits up to £42,475, taken from any earnings above £7,225 and then an additional 2 per cent on annual earnings over £42,500; HMRC collects this (Class 4 NI) along with income tax, as well as £2.50 per week Class 2 NI.

VAT

VAT registration is mandatory for anyone earning over £73,000 per year, but it could be useful for you to register for VAT on a voluntary basis: it basically means you can claim back some of the VAT on expenses such as ink cartridges, hotel bills, phone bills and anti-virus software etc. You must keep accounts strictly and do VAT returns every quarter, or opt into the flat-rate scheme for VAT which at present means you pay HMRC at a flat rate of 12.5 per cent as a fixed percentage of your VAT-inclusive turnover. On a quarterly return basis as a part-time law editor I was around £500 a year better off by being voluntarily registered for VAT; I know a full-time freelance medical editor on the flat-rate scheme who says she is about £1,000 a year better off.

If handling receipts and doing accounts and online forms is easy for you (and you have to keep records for income tax anyway), VAT-registration is an option. But if more form-filling is the last thing you need and you are likely to be unreliable do not venture there: the VAT system is strict and there are penalties for lateness etc. The other thing to consider is the business case: adding VAT onto your invoice will in no way disenfranchise you with publishers, because they will be VAT-registered themselves. They will set off the VAT element elsewhere: i.e. the publisher using your services will still just pay you your fee plus the VAT, but they will then reclaim it from HMRC. However, if you do a lot of work, say, proofreading PhD theses, the students are unlikely to be VAT-registered, and so adding VAT to your bill or to your quote may render you less competitive than another proofreader who is not VAT-registered and will do the work for the same fee without VAT. Records need to be kept for at least six years. PLR is not relevant to VAT.

Royalties

Royalties and advances should be declared for income tax purposes as 'income' (not 'other expenses'). If, God forbid, your book does not sell, 'losses' (i.e. 'unrecouped advances') should

133

be written down as expenses and not as a negative figure on the income side. ALCS with automatically add VAT to royalties from them if you let them have a copy of your VAT registration certificate and fill out a VAT self-billing form. You can also claim VAT on royalties retrospectively from ALCS.

Death and wills, estates

Individuals are exempt on the value of their businesses for inheritance tax through the claiming of business property relief, and authorship and editing is regarded as a business (unless you are retired: keep going?!). The value of copyrights transferred at death will be included in the value of your total assets (if you stop writing more than two years before you die) and so will attract inheritance tax at the rate of 40 per cent once the value of those assets reaches £325,000 for individuals and £650,000 for married couples and civil partners.

Insurance

Writers who fear legal action for negligence on their part (which could mean mistakes as to facts: e.g. on pharmaceutical dosages; or libel; as well as unintentional infringement of copyright and unintentional breach of confidentiality etc.) can take out professional indemnity insurance which will cost a few hundred pounds a year. (I have seen quotes ranging from £140–340 so it is worth shopping around.) Make sure it covers you for claims stemming from parties abroad. Anyone involved in public or private speaking or teaching (taking you out of your home or office into new venues) could consider public liability insurance. And tax protection insurance is available to those who live in fear of a visit from the tax inspector: I know of one scheme which only costs £11 per annum so it sounds like quite a good idea.

Pensions

Saving for a pension is not perhaps a priority for people on very low incomes, and a problem area for many, but the tax system does support and encourage pensions savings plans by all.

Accountants

Most of us can get away with doing our own accounting and tax returns, but if you are busy, or just want peace of mind, accountants can be very helpful: especially if your income changes a lot year-to-

year, or you have unusually high expenses one year so you could benefit from postponing tax payments or generally from 'working the system'. Anyone who has a complicated set-up, such as being in partnership with a spouse, will probably also want help, as will most higher rate tax payers. Accountants can also advise on the most appropriate 'legal entity', by which I mean whether or not you should be a sole trader, partnership, or limited company (the latter being relevant perhaps to people earning above £100,000 a year). The basic cost of a good accountant starts at around £500 per year for a simple case, but this cost is an allowable expense for income tax purposes.

To this brief summary chartered accountant, Stephen Simou of Citroen Wells adds:

'Most authors seem to underestimate what expenses they can legitimately claim for tax purposes in order to offset against their income. This is especially true for higher rate tax payers where the claiming of additional expenses as well as the use of averaging can lead to significant tax and NI savings. VAT is also a bit of a minefield and getting it wrong can prove to be very expensive because Customs charge heavy penalties and interest'.

INFORMATION BANK

All figures and rates quoted in this Chapter apply to 2011–12.

Flat rate schemes: 12.5 per cent is the rate from 4 January 2011 for 'journalism'; the flat rate for publishing is 11.5; for film, radio, television or video production 13.5; for library, archive, museum or other cultural activity, 9.5. See www.hmrc.gov.uk.

20

The Death of Copyright?

By Ian Bloom, Ross & Craig Solicitors

It is a platitude but nonetheless true that the expansion of the internet, the exponential increase in resources available online, the sheer volume of information on Wikipedia and the development of bespoke or customised writing services have all contributed to the growth of plagiarism.

In part, plagiarism may be inaccurate or incomplete referencing rather than intellectual cheating. But it also seems almost generational: attitudes to copyright infringement were formed for those over, say, 35, in the pre-internet age, when the process of research was altogether more painstaking. Nowadays, many young writers seem to regard material that is freely available (relatively few resources on the internet are currently protected by firewalls) as theirs to do with as they see fit. They seem less concerned with sourcing accurately the material they (re)use.

I suspect that in much the same way that bloggers and contributors to sites that invite reader comments do not have libel or privacy consequences in mind when they post their contributions, issues of copyright infringement and properly referenced attribution do not figure large either.

It may well be that the mindset changes if resources can be acquired/accessed without payment and, indeed, without too much hard work. After all, nowadays half-a-dozen clicks can access material that, in previous generations, may have taken weeks to locate. 'Plagiarism is a breach of disciplinary decorum', suggested Professor Stanley Fish recently, 'not a breach of the moral universe. Plagiarism is like that: it is an insider's obsession... an annoying guild imposition without a persuasive rationale ...'.

Kaavya Viswanathan's novel, *Opal Mehta*, was published when she was still at Harvard. She copied so much from other sources that she became a cause célèbre and an internet sensation. Helene Hegemann published a novel in Germany when she was even younger, only 17. Her memorable response to allegations

of plagiarism was *'There's no such thing as originality anyway, just authenticity'*. She also introduced the concept of 'mixing', (or mashing-up) more frequently found in music, as something between a defence and an explanation for her activities. In her own terms, she may have been right. After all, if it is legitimate to 'create' your own sounds by sampling from the music of others, and perhaps adding some material of your own, how much of a 'crime' is it to apply the same techniques to writing? The discussion can extend to reconsidering what 'authorship' actually means in the digital age and how conventional safeguards may not be sufficient to protect conventional copyright holders.

If enough writers, bloggers and journalists consider it reasonable to reuse, without attribution or payment, the work of others 'discovered' by them on the internet, then, to some extent, the system of copyright enforcement breaks down. After all, many drivers speed on a daily basis, some several times in the course of a journey, but if everyone who did so was stopped, arrested, charged and prosecuted, the criminal court system would collapse. Similarly, if every possible claim for copyright infringement was pursued, the civil courts would be hopelessly clogged up and the likely damages per infringement would be disproportionately small compared with the costs of seeking to enforce a claim.

Whilst at present, it is only the flagrant or the high-profile abusers who are likely to get caught and shamed, there are signs that an internet-driven free-for-all could signal the death of copyright as we know it.

INFORMATION BANK

Other reading:

Fish, Stanley (Professor of Humanities and Law at Florida State University), 'Plagiarism is Not a Big Moral Deal' and 'The Ontology of Plagiarism: Part Two' in the *New York Times*, 9 and 16 August 2010, also at http://opinionator.blogs.nytimes.com/category/stanley-fish

Gabriel, Trip, 'Plagiarism Lines Blur for Students in Digital Age' in the *New York Times*, 1 August 2010.

Paul R., 'Traditional Remix v. Digital Remix: A Transforming Conception of Authorship', at http://www.yalelawtech.org/ip-in-the-digital-age

Tom Geoghegen, 'Plagiarism: The Ctrl+C, Ctrl+V boom', in the *BBC News Magazine*, 2 March 2011, also at http://www.bbc.co.uk/news/magazine-12613617

Aaronovitch, David, 'This Column is all my own work. Honest', in *The Times*, 3 March 2011

Appendix I: Copyright in publishing contracts

By Ian Bloom, Ross & Craig Solicitors

Congratulations! A publisher has commissioned you to write a book or (less usually) accepted a typescript you have submitted. They send you a contract. They do not expect you to negotiate its terms – unless you are a successful author with significant sales. (As a general rule, the longer the agreement the more restrictions it will place on the author. Publishing agreements are written by publishers. They exist primarily to protect publishers).

One of the early clauses in the publishing contract is your warranty to the effect that your work is original to you, and that, where necessary, all copyright permissions have been obtained. The last thing the publisher wants is to print and then publish your work, only to receive on, or shortly after, publication, a valid claim for unauthorised copying, leading either to the payment of significant damages or, worse still, the edition being pulped.

Having given that warranty, you are then expected to assign your rights in the work to the publisher. Although, in theory, specific rights should only go to those best able to exploit them for your benefit, in practice, many publishers prefer an assignment of all the rights in the work for all media. Even if they cannot publish in overseas territories themselves, they would hope to sell publishing, serialisation, translation, merchandising and (the Holy Grail) film and television rights, in your work at the big international book fairs (Frankfurt in the autumn and London in the spring).

You may have an agent who says that he or she can do better than the publisher's in-house rights department. Sometimes that is the case. The worst position you can be in is that the original publisher acquires all rights in your work and is entitled, on the sale of individual rights, to an agreed percentage of receipts (the publishing contract sets out in detail who gets what); your agent then takes his or her 10–20% of the balance and you are left with a much smaller residue than the headline figure you thought would be available.

There is no easy way around this – unless you have extraordinarily good media contacts and are sufficiently knowledgeable about publishing/licensing agreements to act for yourself. Representation,

whether by lawyers, accountants, publishers or agents, costs money – be it an hourly fee or a fixed percentage of receipts.

However, representation can be invaluable. It can lead to a materially better deal. Quite apart from negotiating the best advance and royalty payments (including e-book royalties); limiting the circumstances whereby the publisher can reject the commissioned work; agreeing the reversion of rights if/when the work goes out-of-print; specifying the respective obligations for libel reading; providing a mechanism for resolving disputes and ensuring other key clauses are fair (some agreements are over 20 pages long nowadays), you should not waste your creative energies on doing work best left to specialist advisers.

The trick, of course, if you are unknown, is to find a representative: it can be as difficult to be taken on by a good agent as it is to find a good publisher. And if publishers only deal with agents – and often only with agents they know and trust – you can face real problems just getting started.

For publishing agreements, look at the Publishers' Association's Code of Practice 2010 (www.publishers.org.uk), or you can buy, or at least read, *Clark's Publishing Agreements*, now in 8th edition (Haywards Heath: Bloomsbury Professional 2010). It is the 'Bible' of publishing contracts and contains practical precedents and very helpful commentary. The Society of Authors also publishes a guide to publishing contracts which is free to members, £10 to non-members.

For representation, start with the *Writers & Artists Yearbook* – and persevere!

Appendix II: Copyright/imprint pages

First published in Great Britain 2011
A&C Black Publishers
an imprint of Bloomsbury Publishing Plc
50 Bedford Square
London, WC1B 3DP
www.acblack.com

ISBN: 978-1-4081-2814-5

A CIP catalogue record for this book is available from the British Library

Cover design: Sutchinda Thompson
Series and page design: Susan McIntyre
Publisher: Susan James
Managing editor: Davida Saunders

Cover illustration © Gillian Davies and Tami Cohen 2011

This book is produced using paper that is made from wood grown in managed, sustainable forests. It is natural, renewable and recyclable. The logging and manufacturing processes conform to the environmental regulations of the country of origin.

Printed and bound by Star Standard Pte Ltd, Singapore

There is no legal need to use the © **symbol**. The work is protected by UK copyright law even if no symbol appears with it. But the symbol is useful evidentially and in relation to defences: see p.64, 70 and 71.

The **date** should be the date of first publication: 'The copyright notice does not, under normal circumstances, change at any time and should continue to be printed with the same date of first publication anywhere in the world in all editions of a book as long as it remains in copyright. Thus a book first published in the USA in one year and in the UK the next retains the date of the US publication in the copyright notice. The only current exception is when a substantially revised edition of a book is published, in which case it may be legitimate to amend the copyright notice to say, "Copyright © in this revised edition by…".'

Publishers Association, http://www.publishers.org.uk/images/stories/AboutPA/The_copyright_notice.pdf

Moral rights assertion: if an author does not assert his or her right to be identified with their work, he/she will enjoy no paternity right. The law is very clear on that. If an author chooses to waive moral rights, such a waiver can be documented away from the book or be included on the imprint page (although the latter is very rare). A paternity right assertion can be 'specific' or 'general' (s.78(2) of the Copyright, Designs and Patents Act).

Joint copyright (see p.120–21): in asserting paternity rights where there are joint authors, each author should assert the right for himself or herself. Note however that if a publisher were to publish one assertion without another (say, one author didn't reply to correspondence or couldn't be found), this could technically amount to 'false attribution', with the publisher ultimately potentially culpable of 'reverse passing off'. I cannot think of any practical situation where this would arise, as most publishers send proofs to all authors, and all authors would therefore see the imprint page and moral rights assertions, but this is noted as a technicality. The safest course for publishers is to name both authors. Note also that, 'the paterntity right does not give an author any right NOT to be named as the author or a work of his'.

Copinger and Skone James (16th edn), para.11–23 and n.135.

Appendix III: Permissions requests

Please see Chapter 7, Quoting/Extracts and Chapter 10, 'Orphan Works'.

Most publishers have their own permissions forms and letters. However, a basic one would look like this. It is a good idea to also attach a form that can be filled in repeating the information you are requesting with blanks for answers. Send two copies.

[Addressee]
[Date]

CONFIDENTIAL
Pre-press enquiry regarding forthcoming new publication: [*name of author/publication*]

Dear Sir or Madam,

I am a [*freelance writer/editor/publisher*] working on a book about [*xxx*] entitled [*xxx*]. [*Optional additional information about publication/author/publisher*].

I am writing to you to check the copyright status of the following quote:

'xxx xxxxxx xxxxxx xxxxxxx xxxxxxx x xxxx x xxxxx xxxx.'
[*title, author, date, publisher*].

I would be grateful if you could advise on the following questions:
- Is the quote correct as I have it here?
- Do we have permission to reproduce it taking into account our requirements (listed below)?
- Does the author/artist/publisher have any additional comments/restrictions/requirements that we should be aware of?[1]
- Are you able to confirm that you are authorised to grant this permission and the quoted material/work is not otherwise encumbered by any competing copyright claims in your knowledge?

[1] This provides the source from which you are requesting permission the opportunity to request proofs or ask to see the whole book or an extract; to prohibit cropping etc.; or request credits/acknowledgements etc.

- If you are not the copyright owner of this material can you advise us if you know who is?

Our intended use/requirements
- [*Title of book*]
- [*Author*]
- [*ISBN/ISSN*]
- [*Print run*]
- [*Planned publication date*]
- [*Sales territories*]
- [*Language*]
- [*Size and resolution of image as reproduced/length of quote to be used*]
- [*Special terms of usage required, e.g. cover/planned alterations etc.*]

We shall assume we have consent to publish the quote if we do not hear from you within [30 days] of the date of this letter.

Thank you very much for your assistance in advance,

Yours sincerely

[*Your name*] [*Address*] [*Email/telephone number*]

Other useful resources

The International Association of Scientific, Technical and Medical Publishers has its own guidelines for quotation and academic use of exerpts from journal articles: see www.stm-assoc.org.

Resources

Legislation

Copyright, Designs and Patents Act 1988,as updated http://www.opsi.gov.uk/RevisedStatutes/Acts/ukpga/1988/cukpga_19880048_en_1

Duration of Copyright and Rights in Performances Regulations 1995 (1995 No. 3297) http://www.opsi.gov.uk/si/si1995/Uksi_19953297_en_1.htm

Books

Banks, David and Hanna, Mark (eds), *McNae's Essential Law for Journalists* (20th edn) (Oxford: OUP, 2009)

Bently, Lionel, *Between a Rock and a Hard Place: The Problems Facing Freelance Creators in the UK Media Market-Place* (London: Institute for Employment Rights, 2002)

Bently, Lionel and Sherman, Brad, *Intellectual Property Law* (3rd edn) (Oxford: OUP, 2009)

Bonnington, Alistair J. and McInnes, Rosalind, *Scots Law for Journalists* (8th edn) (Edinburgh: W. Green/Sweet & Maxwell, 2010)

Cornish, G. P. and Chartered Management Institute, *Copyright in a Week* (London: Hodder & Stoughton, 2002)

Cornish, William, *Cases and Materials on Intellectual Property Law* (5th edn) (London: Sweet & Maxwell, 2006)

Garnett, Kevin, Davies, Gillian* and Harbottle, Gwilym (eds), *Copinger & Skone James on Copyright* (16th edn) (London: Sweet & Maxwell, 2011). *Please note this is a barrister called Gillian Davies, not the author of this book.

Herbert, Jo (ed.), *Writers and Artist's Yearbook 2011* (London: A&C Black, 2010)

Pedley, Paul, *Copyright Compliance: Practical Steps to Stay within the Law* (London: Facet Publishing, 2008)

Shay, Helen, *Copyright and Law for Writers: How To Protect Yourself and your Creative Work* (4th edn) (Oxford: How To Books, 2008)

Wild, Charles, Weinstein, Stuart, MacEwan, Neil and Geach, Neal (eds), *Electronic and Mobile Commerce Law: An Analysis of Trade, Finance, Media and Cybercrime in the Digital Age* (Hatfield: University of Hertfordshire Press, 2011)

Essays and Features

Society of Authors, http://www.societyofauthors.org, has useful guidelines including: 'Model Permission Letter,' 'Quick Guide to Permissions', 'Guide to the Protection of Titles' and 'Publishing Contracts'.

Solomon, Nicola, 'What a Character!' in *The Author* (Spring 2001: <page ref?>).

Shepherd, Lynn, 'Sincerest flattery?' in *The Author* (Autumn 2010) By the author of *Murder at Mansfield Park*, this article deals with the subject of transformative works/adaptations/sequels, interquels, literary ventriloquism, 'mash-ups', plagiarism, piracies, imitations and rip-offs.

Pila, Justine, 'An International View of the Copyright Work' [2008] 71(4) MLR 535–58.

Jassin, Lloyd J., 'Termination of Book & Music Publishing Copyright Contracts' on the *Copylaw* website, www.copylaw.org/p/termination-of-book-music-publishing_17.html and 'Copyright Asteroid Hurtling Toward Earth, Impact Due 2013', http://ereads.com/2010/09/copyright-asteroid-hurtling-toward-earth-impact-due-2013.html (Mainly US copyright relevant.)

Websites

WATCH database, http://research.hrc.utexas.edu/watch/about.cfm

FOB (Forms out of Business), http://research.hrc.utexas.edu/watch/fob.cfm

Own-it, http://www.own-it.org. Own it is a free, London-based legal (intellectual property) advice service online with real world training courses.

PLS Annual Copyright Meeting 2010, http://www.pls.org.uk/news/Pages/openmeeting2010.aspx?PageView=Shared

Index